HISTORIC
SANIBEL
&
CAPTIVA
ISLANDS

HISTORIC SANIBEL & CAPTIVA ISLANDS

ISLANDS

Tales of Paradise

JERI MAGG

THE
History
PRESS

Published by The History Press
Charleston, SC 29403
www.historypress.net

Back cover images courtesy of the Sanibel Historical Museum and Village.

First published 2011
Second printing 2012
Third printing 2013

Manufactured in the United States

ISBN 978.1.60949.355.4

Library of Congress Cataloging-in-Publication Data
Magg, Jeri.
Historic Sanibel and Captiva Islands : tales of paradise / Jeri Magg.
p. cm.
Includes bibliographical references.
ISBN 978-1-60949-355-4
1. Sanibel Island (Fla.)--History, Local. 2. Captiva Island (Fla.)--History, Local. 3. Historic
buildings--Florida--Sanibel Island. 4. Historic buildings--Florida--Captiva Island. 5.
Historic sites--Florida--Sanibel Island. 6. Historic sites--Florida--Captiva Island. 7. Sanibel
Island (Fla.)--Biography. 8. Captiva Island (Fla.)--Biography. I. Title.
F317.S37M34 2011
975.9'48--dc23
2011040348

Contents

CONTENTS

Acknowledgements

This tome could not have been completed without the assistance of so many. I'd like to thank photographer Manfred Strobel for taking so much time and effort to get the "right light" for the photos. Kudos also to my good friends and members of our writers' critique group: Carol De Frank, Pat Janda and Martha Jeffers, who edited my pages along the way.

With special thanks to Martha Jeffers, a great copyeditor, who made sure the grammar was correct. Candy Heise, research librarian at the Sanibel Library, is owed my gratitude for allowing me to scan the historic photos in this book.

I also appreciate the historical expertise of Alex Werner, president of the Sanibel Historical Museum and Village, for checking the facts, and Deb Gleason, chairman of the Historical Preservation Committee, who took the time and effort to support my endeavor. And lastly, special thanks to my wonderful husband, Karl, to whom I owe the most recognition. As always, he was there to encourage, support and help whenever necessary.

BEGINNINGS

Warm beaches, exotic shells and the tropical sunsets of Sanibel and Captiva Islands attract thousands of visitors each year. Some buy a piece of paradise and stay, but most enjoy the abundant flora and sea life and promise to return. Few realize that long ago, others roamed these same shores for very different reasons.

Stories abound on how the islands got their names—some factual, some folklore. When the Spanish first anchored offshore in the 1500s, they called the two islands *Costa de Caracoles* ("Coast of Sea Shells") because of the beautifully colored mollusks strewn along the shoreline.

By 1768, sailors referred to Sanibel by the Spanish "Nibel," meaning "level" because the islands appeared parallel to the horizon. A later mapmaker interpreted the abbreviation "S" to mean san or saint—thus San Nibel. A 1775 mapmaker changed San Nibel to Sanibel, and it stuck. Captiva first appeared on Spanish maps as Cautivo, meaning "single male captive."

THE CALUSA

About five thousand years ago, primitive nomadic Indians of moderate height with dusky skin and long black hair moved into the Florida peninsula. Called mound people, pile dwellers or Calusa (red men), they built mounds of shell or clay.

Their fishing villages were constructed of long, sturdy pilings pounded into the sea bottom. Platforms were fastened to pilings, and atop each

SANIBEL ISLAND

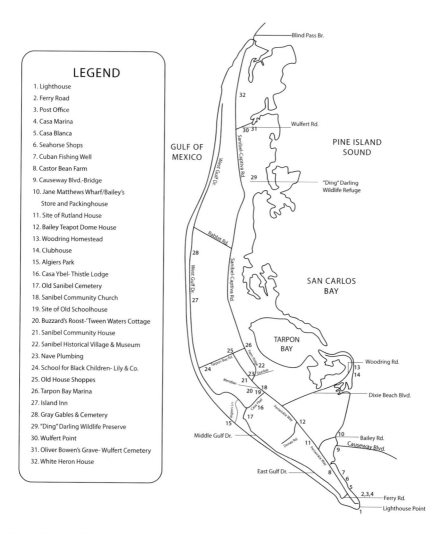

Blind Pass Br.

LEGEND

1. Lighthouse
2. Ferry Road
3. Post Office
4. Casa Marina
5. Casa Blanca
6. Seahorse Shops
7. Cuban Fishing Well
8. Castor Bean Farm
9. Causeway Blvd.-Bridge
10. Jane Matthews Wharf/Bailey's
 Store and Packinghouse
11. Site of Rutland House
12. Bailey Teapot Dome House
13. Woodring Homestead
14. Clubhouse
15. Algiers Park
16. Casa Ybel- Thistle Lodge
17. Old Sanibel Cemetery
18. Sanibel Community Church
19. Site of Old Schoolhouse
20. Buzzard's Roost-'Tween Waters Cottage
21. Sanibel Community House
22. Sanibel Historical Village & Museum
23. Nave Plumbing
24. School for Black Children- Lily & Co.
25. Old House Shoppes
26. Tarpon Bay Marina
27. Island Inn
28. Gray Gables & Cemetery
29. "Ding" Darling Wildlife Preserve
30. Wulfert Point
31. Oliver Bowen's Grave- Wulfert Cemetery
32. White Heron House

GULF OF MEXICO

PINE ISLAND SOUND

Wulfert Rd.

"Ding" Darling Wildlife Refuge

SAN CARLOS BAY

TARPON BAY

Woodring Rd.

Dixie Beach Blvd.

Middle Gulf Dr.

Bailey Rd.

Causeway Blvd.

East Gulf Dr.

Ferry Rd.

Lighthouse Point

Map of Sanibel historical sites. The numbers in the legend correspond to the numbers used throughout the book. *By Julie Scofield.*

foundation stood a chief's house, the village, storehouses and a temple. On the lower levels were thatched dwellings for the servants.

The men—tall, attractive and powerfully built—dressed in deerskin loincloths. The women, lithe and good-looking, donned short aprons of Spanish moss, and the children wore nothing at all. Their diet consisted of fish and mollusks. Only the chief and his wife displayed jewelry, usually pearl

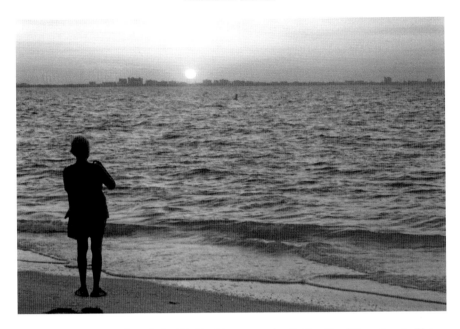

A Sanibel sunrise seen from Point Ybel looking across the Gulf to Fort Myers Beach. *Photo by Manfred Strobel.*

and stone necklaces. While Calos, the capital, may have boasted more than one thousand inhabitants, the typical village had no more than three hundred. The Indians were excellent sailors, lashing two canoes together for voyages to Cuba and other Caribbean islands where they traded on a regular basis.

When the Spanish came in the late 1400s, Calusa lived on Sanibel and Captiva. The waterways of Pine Island Sound, Charlotte Harbor and Estero Bay were central for the tribe, the most powerful at the time. The politically savvy chief, or head "cacique," of the Calusa manipulated the Spanish to obtain goods, and the number of converts to Catholicism mirrored the amount of corn and cloth given as gifts.

The Spaniards

Records show that Spanish explorer Juan Ponce de Leon first met the Calusa somewhere in San Carlos Bay in 1513. As one story relates, the Spaniards, anchored near shore, became alarmed and then angry when several canoes approached the ships and the Indians tried to seize the chain of an anchor being repaired. The sailors launched a boat, beat off the attack and pursued the Indians to the beach, taking four women hostage.

The Indians made several more attempts to board the explorer's ship, and during the final battle, the Spaniards killed eighty warriors. Wearied by this latest bloodbath, the Spaniards returned to Spain. Touting his many accomplishments, Ponce de Leon was honored by the Spanish king and immediately set out to raise another expedition.

Eight years later, he foolishly returned to the San Carlos Bay area with horses, cattle, equipment and 200 colonists. The Calusa, still angry about the slaughter of 80 Indians, watched the white men disembark at Punta Rassa. The exhausted voyagers rested and, within a few days, began building a settlement. The Calusa took the colonists by surprise. During this attack, 80 Spaniards were killed, and Ponce de Leon received an Indian arrow in the thigh, a wound that proved fatal. About 160 Indians died in this battle, but the survivors felt victorious after the demoralized settlers headed home. Loading their leader on the ship, the Spaniards sailed to Puerto Principe, Cuba, where the battle-scarred explorer died.

It was eighteen years before the next invaders passed the tip of Sanibel at Point Ybel; Navarez was the first in 1529, and De Soto followed in 1539. Both expeditions were repelled by the wily Calusa, who slaughtered many.

In 1566, Pedro Menendez de Aviles used force and flattery to make friends with the Calusa. He sought to convert rather than conquer them and asked Jesuit priest Father Juan Rogel to stay among the warriors. Even knowing that the Calusa were turbulent and intractable, the good padre believed they needed help and suggested sending the young people to Cuba to be educated.

Menendez de Aviles had everything to lose if his efforts failed. His reward from the King of Spain included two profitable island fisheries and twenty-five square miles of land. He returned to St. Augustine, leaving Rogel and his priests to convert the natives and establish religious colonies. Calusa Chief King Carlos and his warriors resisted this forced conversion and tried to slaughter the priests. Hearing this, Menendez de Aviles returned, rounded up eighteen of the fiercest chiefs from the embattled towns, including King Carlos, and marched the men to Punta Rassa, where they were beheaded. After their deaths, the mound people were mostly forgotten, and the explorer left the area to fortify St. Augustine.

The islands remained attractive as a trading route and fishing area. Point Ybel continued as a navigational spot where colored sails and three-decked treasure ships lumbered down the Gulf shore, carrying loot from Aztecs, Mayans and South American Incas. From this point, they sailed south by southwest toward the Tortugas and Cuba.

Spaniards used the islands for surprise raids to capture natives. By 1708, a slave route had been established around Point Ybel, north up the Caloosahatchee River, across Lake Okeechobee and then northward along

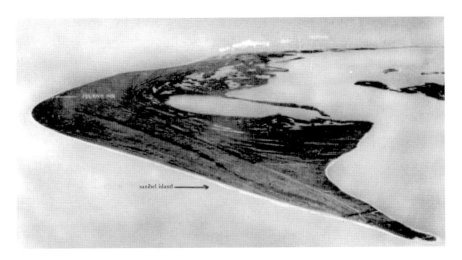

Photo of Sanibel Island taken in the 1950s. This island is twelve miles long and four miles wide. *Courtesy Sanibel Public Library.*

the eastern Florida coast to the English colonies in Georgia. The slavers made money, whether selling Africans or Indians.

The deep-water channels acted as hideaways for pirates who preyed on passing frigates. The Indians traded with these thieves and were content to live with the teeming waters, wild birds and abundant fish.

The Calusas' lives changed in 1763 after the Treaty of Paris ceded Florida and the barrier islands to the English. The Indians, who had formed strong friendships with the Spanish, distrusted the English and high-tailed it to Key West and then on to Cuba.

Following the American Revolution, England returned Florida to the Spanish in 1783. Spain, now weak and poor, cared little about its colonies in Florida. This situation left the Indians in peace and allowed Cuban fishermen to work unhindered. But the emerging country of the United States pressured Indian tribes living in the thirteen colonies to flee into the Florida territory. Spain soon realized it could never maintain Florida as a possession and ceded it to the United States in 1821.

THE AMERICANS

Americans envied the Cubans' fishing livelihood and headed to Florida.

At the same time, the Florida Peninsular Land Company offered fifty shares of stock to anyone willing to establish a colony in south Florida. One share equaled 1,800 acres of land and sold for $500. Taking advantage

of this offer, a group of adventurers traveled from Key West to the islands in 1822.

Northerners had a choice of three areas between Cape Romano and Tampa Bay. Their agent spent a month exploring the lower Gulf coast, paying special attention to the San Carlos Bay area. Noting its good harbor and fertile land, he disembarked on Sanibel. Two towns were proposed—Murray and Sanybel—each requesting and receiving incorporation papers. Only Sanybel materialized.

A large house and several smaller ones were erected at Point Ybel so newcomers could live and trade while building homes on the island. A crop of sugar cane was planted, but the threats of attack by the Seminole Indians, incessant heat, sand fleas and lack of a mainland town for commerce forced most of the settlers back to Key West.

At about the same time, the Spaniards learned that Florida's terrain was excellent for cattle grazing. By the middle of the 1800s, northerners were buying land to raise beef, and before long, the state enjoyed a thriving business.

From 1861 to 1865, the Civil War impacted the islands. John McKay, captain of the side-wheeler *Scottish Chief*, supplied the Confederacy with cattle and drove herds north through the state of Florida to Georgia. Sensing that the South would lose, he teamed with Jake Summerlin, a local rancher, to sell cattle to the Spanish government. McKay and Summerlin drove livestock from the interior of Florida to Punta Rassa (Spanish for "cattle point") and loaded the beef onto schooners sailing to Havana. The returning ships brought guns and supplies for the Confederates living on the islands around Charlotte Harbor. So flagrant was their business that the Federal government sent nine gunboats to patrol the area and, after a few weeks, destroyed the illegal supply lines. Undaunted, McKay and Summerlin moved their operations to other spots and quickly informed the Confederates, who sneaked back to buy the guns and grain.

During this time, a number of other factors contributed to the continued fascination with the islands. Congress passed the Homestead Act in 1862, allowing any American citizen to acquire 160 acres free if he or she agreed to cultivate the land for five years. Many Civil War blockade runners, as well as citizens hurt by the depression following the war, decided to relocate to southern Florida.

The arrival of telegraph lines also encouraged development of the area. The Inter-Ocean Telegraph Company of New Jersey took over the barracks and buildings of old Fort Delaney at Punta Rassa in 1876. Soon, telegraph lines were strung on poles through Florida via Punta Rassa and under the

Jake Summerlin became one of the state's wealthiest cattle barons before reaching the age of forty. *Courtesy Sanibel Public Library.*

waters to Key West and Havana. Now islanders were able to communicate with the outside world.

Cuban cattle ships carrying unlimited orders for beef from the Spanish government made Jake Summerlin so wealthy that he erected Summerlin House at the old port. But his ships were in danger of running aground because of the difficulty in navigating in the dark around Point Ybel. Requests for a lighthouse dated back to 1856, but it took twenty-eight more years before one was built.

Finally, Sanibel was fully opened to homesteading in 1885. By the beginning of the twentieth century, Captiva was also opened to homesteading, and Henry Plant's railroad, used for shipping cattle, finally pulled into Fort Myers in 1904.

For the next sixty years, only the hardiest came to the islands—not quite the paradise it is today—and tilled the soil, fished the backwaters, raised

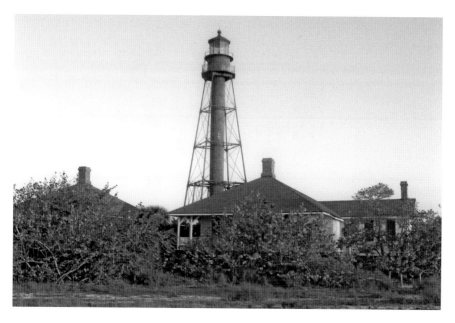

The Sanibel Lighthouse and cottages today. *Photo by Manfred Strobel.*

families and built the foundations for our modern Sanibel and Captiva. Clouds of mosquitoes, frequent hurricanes and Indian wars chased most pioneers away. Those who stayed had to overcome many obstacles before they managed to establish a good quality of life for their families.

Visitors and residents can recount the many tales of Sanibel and Captiva by following the site maps included in this book. By traveling from the lighthouse end of Sanibel to the tip of Captiva, vacationers and islanders will learn about the pioneers who built these sites—how they lived, worked, worshipped and died.

Let us begin our journey.

POINT YBEL

The Sanibel Light (#1)

Eyewitness accounts described Point Ybel as "high ground, miles of shell roads, bordered with flowers and grass." After the Civil War, Union army blockade runners, Confederate sympathizers and Florida cattlemen searched for a place to start a new life, and Sanibel and Captiva fit the bill. The only downside for these rough-and-ready pioneers was the lack of a lighthouse to illuminate Point Ybel for commercial boaters and fishermen.

In the late 1880s, this tip of land was chosen for placement of a 104-foot-high lighthouse. Its slender inner cylinder, braced 20 feet off the ground by an iron column, was supported by a pyramid-shaped frame of latticed wrought iron that offered little resistance to high winds. The French-built giant lens was mounted in brass and revolved by means of intricate clockworks around a fixed frame.

The completion of the Point Ybel Lighthouse in 1884 guaranteed the safety of commercial and passenger vessels arriving on the island. One year later, a 162-foot-wharf and two wooden cottages constructed on iron stilts were completed, and for the first time, the light was visible to ships twelve miles out to sea. The cottages consisted of four large, high-ceilinged rooms with one window and a door leading to the porch. Heat came from a fireplace. A privy was used until an indoor bathroom was added. Nearly 670 acres were preserved to provide the keepers with pasture and farmlands.

Dudley Richardson and Henry Shanahan were hired on as lighthouse keeper and assistant in the late 1880s. When Richardson resigned in 1892, Shanahan applied for his position. His inability to read or write almost cost him the job, but after threatening to resign, he became keeper.

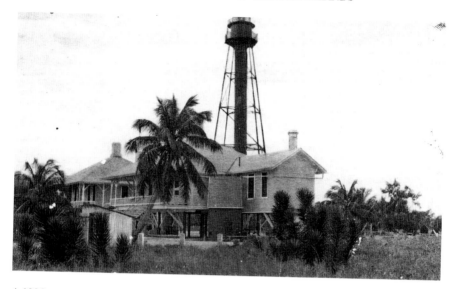

A 1926 postcard of the Sanibel Lighthouse and cottages. *Courtesy Sanibel Public Library.*

Only five families lived on the island at the time. Shanahan, a widower, needed help raising his seven children and married an island widow, Irene Rutland, who had five children of her own. They, in turn, had a child. The chaos inside the small quarters with sixteen people dashing about was taken in stride by the family. There was always plenty of time for fun after the work in the pasture or the lighthouse was finished. The children loved to play with the keeper's pet deer that acted more like a dog racing up and down the beach. Shanahan also had a trained cat that would roll over like a dog and was able to catch milk from a cow's udder. In his spare time, Shanahan made replicas of the keeper's cottages large enough for the children to play house. They were perfect in all details and lasted until a storm blew them away.

Every morning, Shanahan or his assistant climbed ninety-eight steps, extinguished the flame, trimmed the wick, wound the clockworks, polished the glass and shut the curtain that protected the lens from the powerful rays of the sun. In the evening, he filled the huge lamp with oil and lit it. Then the keeper was free for other duties, including minding the other aids to navigation, the lighthouse dock and the grounds. For all this work, Shanahan received $740 a year; his assistant, son Eugene, earned $600. His stepson, Clarence Rutland, who helped at the lighthouse, describes the routine: "There were two men. We changed watch each night at 12:00. It was oil light and we'd take a can up full in the afternoon and pump the light and bring the can down empty in the morning. The light had clockworks on it

and you had to keep it flashing to the second. Somebody had to be with it almost every minute."

Lighthouse stories are plentiful. One of the more comical took place during a hurricane when a crew of Cuban fishermen came ashore seeking shelter. As it happened, the wife of the keeper, Irene Shanahan, was pregnant, so the Cubans took over all duties of cooking and cleaning. In those days, a garden and a privy were located on the shore. When the hurricane subsided, the expectant mother rushed to the privy. Thinking no visitors were around, she left the door open and gazed at the tumultuous sea. As she sat on her "throne," four Cubans meandered down the beach. Horrified, she watched them approach. Sensing her predicament, one of the sailors stepped forward and bowed from the waist, as if to a queen, and continued walking. Following his lead, the other sailors bowed and proceeded down the beach, thus avoiding an embarrassing moment for all.

The U.S. Coast Guard took over lighthouse operations in 1939. Three years later, a lookout tower was erected nearby so that German submarines could be spotted. A third cottage was built for a special detachment of guardsmen who patrolled area beaches by jeep, searching for enemy landings. This fear of German invasions was well founded after a German U-boat sank west of Gasparilla Island.

No aliens were admitted to the States during the war, but that didn't stop them from trying. One night, two Cubans stole a dingy from their fishing smack (boat) and landed on the island. They hid the craft and themselves in the marshes beyond the point. In the morning, their captain reported them to the U.S. Coast Guard, which prompted a manhunt into the palmetto scrub and swamp. The fugitives were captured in an orange grove near Bailey's Store.

Sanibel Light became a flasher during World War II after it was converted to acetylene gas (colorless and flammable) with a sun valve that utilized the rays to turn it on and off.

Coast Guardsman Bob England, along with his wife, Mae, and infant daughter, Margaret, came to the lighthouse in 1946. Because of the ferocious mosquitoes, Mae wore a bee veil, leather jacket and gloves just to hang her clothes out to dry, and her husband dressed similarly when working outside. Only a strong offshore breeze helped prevent the pests from taking over the beach. One day, Mae threw open the door and sprayed repellent into a cloud of mosquitoes hovering by the water cistern. Later, she reportedly found dead insects piled eighteen inches high.

The Englands had two pets at the station. The more traditional was their dog Tuffy, but the second was a huge jewfish (a type of sea bass

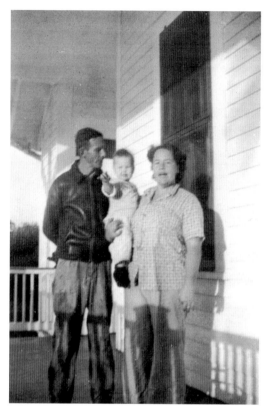

The England family—Bob, Margaret and Mae—in front of their cottage at the Sanibel Lighthouse. *Courtesy Sanibel Public Library.*

that can weigh up to seven hundred pounds) that lived under the station's dock. The fish served as a natural garbage disposal, devouring all the scraps the family could feed it.

Sanibel Lighthouse was eventually automated in 1949, and England was given a new assignment. In June of that year, the Fish and Wildlife Service negotiated a permit with the Coast Guard, and the buildings became the headquarters for the J.N. "Ding" Darling National Wildlife Refuge.

Starting in 1958, Charles LeBuff worked for the refuge and lived for twenty-one years with his family in the assistant keeper's cottage. He has chronicled his life in the book *Sanybel Light: A Historical Autobiography.*

The Coast Guard gave LeBuff some official duties. One was to help install the 225-pound tank of acetylene gas for the light. Every six months, three new cylinders of the combustible gas were hoisted into place at the base of the lighthouse staircase using a heavy rope pulled by his military jeep.

Charles and his wife, Jean, raised two children during their years at the lighthouse. Their son Chuck considered it his "personal jungle gym." The whole family climbed the ninety-eight steps to watch NASA launches in the 1960s. Today, LeBuff is one of the few islanders who remembers Sanibel "B.C.—Before the Causeway."

LeBuff was Sanibel's 155th registered voter; today there are more than 6,000. The island incorporated in 1974, and LeBuff was elected one of the original city council members. He moved from the station in 1979 but didn't retire until 1990. In his book, he writes: "There's one very special element missing in my everyday life: the close, constant and faithful flash

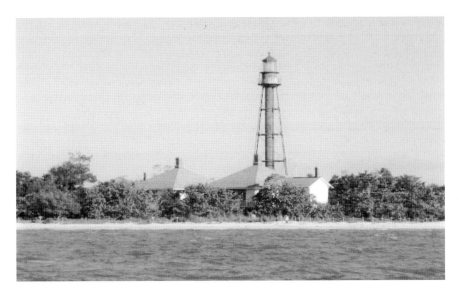

The Sanibel Lighthouse beach today as seen from the water. *Photo by the author.*

that is generated each night after dark from inside the lantern room of the Sanibel Lighthouse."

The light was electrified and the drum lens replaced in 1962. One very much like it is now on display at the Sanibel Historical Museum and Village's Burnap Cottage, along with other lighthouse memorabilia.

The Coast Guard wanted to extinguish the light in 1972, but the public outcry reversed its decision. The people of Sanibel viewed the flashing light as part of their island's unique history and character. In 1982, the City of Sanibel took over management of the station, except for the lighthouse tower. Today, city employees live at the station and maintain the buildings and grounds.

Bob England, who died at the age of eighty, visited the lighthouse in 1993 and climbed the stairs for the first time in forty-two years. He made the following observation: "Years ago, I could make it to the top in a minute and a half. Once in a while I'd stop to look out the windows on the way up. It always fascinated me because the scenery changed hour by hour."

The property was transferred from the Coast Guard to the Bureau of Land Management (BLM) in 2000. The BLM accepted an application from the City of Sanibel for custody of the property in 2004, and after a lengthy delay, the lighthouse was officially transferred to the city during a ceremony held on April 21, 2010.

Sanibel Light still remains—sentinel for sailors and a guide for the island's many visitors.

Chapter 2

ISLANDERS COME BY SEA

Ferry Road (#2)

Word quickly spread that Sanibel's soil was excellent for truck farming. By 1889, there were twenty-one houses and forty families living on the island, bringing the total population to one hundred. By that time, Sanibel, Captiva and Buck Key were flourishing agricultural communities. Growers loaded the stern-wheeler *St. Lucie* with products destined for the mainland and northeastern markets. The double-decker boat sailed round trip daily except Sunday from Fort Myers to Punta Gorda.

When the Atlantic Coastline Railroad was extended to Fort Myers in 1904, George and Andrew Kinzie's Steamship Line won the contract to carry mail to the islands. The stern-wheeler *Dixie* became the island's lifeline, delivering passengers, mail and freight. In 1928, they expanded their line by purchasing a two-year-old car and passenger ferry service between Punta Rassa and Sanibel. At that time, the ferry stopped near the original Bailey's Store on the bay at Matthews Wharf. In an effort to shorten the fifty-four-minute ride, the Kinzies searched for a new departure point.

FERRY LANDING

They obtained a lease from the Lighthouse Board for a thirty-foot-wide strip of land across Point Ybel. Purchasing property along the east side of the land in 1937, they installed a ferry landing and bought an additional twenty-five acres on the west side of the tract. On the bay side, they erected a small dock with a boathouse and cleared a road to the Gulf. Upriver travelers

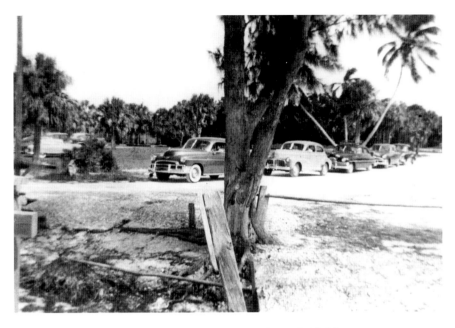

Cars lined up to board the ferry in the 1950s. *Courtesy Sanibel Public Library.*

could then ride to the island, walk across to the shore and enjoy gathering seashells until the steamer returned in late afternoon.

However, there was one glitch—visitors wanted their cars on the island. The wealthiest had them dismantled, brought across via steamer and reassembled. This was an expensive and time-consuming practice. The brothers, spotting an opportunity to make money, added larger steamers able to carry automobiles, and by the early 1950s, service was extended to a fleet of four boats.

THE FERRIES

Once the Kinzies took over the routes, more vessels were bought to access the island. The ferry *Best* was soon joined by bigger boats: *Rebel, Islander* and *Yankee Clipper.*

Maintaining the ferries was sometimes quite difficult. During a 1982 interview, Jerry Lauer, a ferry employee, commiserated about having to crawl under the cars on the deck to get down and attend to the engines.

Captain Leon Crumpler worked on the *Dixie*. After earning master's papers, he took charge of the ferries when auto service began in 1928.

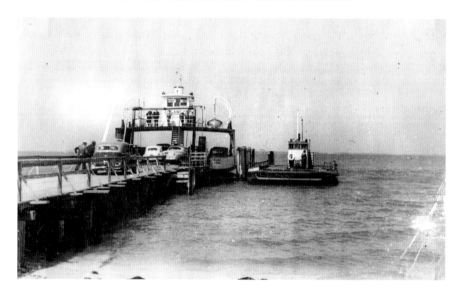

The ferry *Islander*, which could hold up to twenty cars, loads while the *Best*, a passenger ferry, waits alongside. *Courtesy Sanibel Public Library.*

According to locals, he never left a traveler stranded or refused to bring someone across from Punta Rassa. As traffic increased, so did the running schedule, although all ferry service remained limited to daylight hours.

For thirty-five years, Crumpler played host to islanders and travelers, and upon retirement, he described his chief hobby as "reminiscing." He had many stories to tell. One concerned an islander who put his car in reverse instead of forward and shot backward over the stern into the water. A male passenger dived in to tie a rope to the submerged car's axle for the purpose of hoisting it from the water. Another passenger had a bottle of moonshine, and each time the diver came up for air, the passenger offered him a drink. The diver kept going down and coming up, seemingly unable to get the rope attached. All the while, he was happily diminishing the contents of the bottle. Eventually, the hitch was made, and the ferry pulled the car to shallow water. A line was then attached to a moving van and the car brought to shore. Once the car dried out, it ran as good as new.

Islanders chuckled when talking about boarding the ferry. It was quite a feat to navigate down a three-foot-wide ramp at low tide. As the car eased down, the boards clanked. Crumpler would motion to turn right or left to position the car onto the boat. Since some of the female drivers were frightened, he often drove their cars onto the ferry. At a dinner islanders gave in his honor for his seventy-first birthday, Crumpler recalled some of his famous passengers: "Thomas Edison and Henry Ford were ferry addicts. Edison was

hunting rubber sources and came to the island to find plants, shrubs and vines, which he took back in his car to work on at his upriver laboratory."

It is said that Crumpler knew when any of the island women were pregnant—sometimes before their husbands. They'd take the ferry to the mainland to see a doctor and then inform the captain of their condition in case an emergency trip back to the mainland was necessary.

Crumpler rode across the bridge in the lead car the day the causeway opened in 1963. Earlier that day, a standing-room-only crowd of sentimental ferry riders made a tearful final voyage. Leon Crumpler died in 1977.

Over the years, many ferries were commandeered for other duties. During World War II, the *Islander* was requisitioned to become a transport to shuttle troops.

Curtailment of ferry service forced residents to use the mail boat *Santiva* to get to the mainland. It never failed to arrive, good weather or bad. Folks would ride upriver one day, shop the next and return the third.

The Old Post Office (#3)

To islanders, mail was their lifeline. Before an official building housed the postal service, the first office on Sanibel was at Gray Gables, the home of Laetitia Nutt. Appointed postmistress from 1889 to 1895, she trekked an almost five-mile path filled with bramble bushes and snakes from her home on West Gulf Drive to Matthews Wharf to pick up the mail. From 1891 to 1895, Captain George Cooper also collected mail at St. James City. An auxiliary postal drop-off was established when William Reed appointed himself postmaster in 1894. He called the office "Reed, Florida." To end the confusion, on April 1, 1895, the name was officially changed to Sanibel. This office, first located in the Reed home, moved to an adjoining building that housed a tiny store. It finally became a stand-alone frame building on the bay side of the island.

By the 1900s, mail sacks were thrown off steamers at Reed's dock on Matthews Wharf and dispatched by carrier to the frame post office on Ferry Road. From there, a rural-free-delivery carrier took most of it via horse and buggy over Tarpon Bay Road and along Periwinkle Way to the American Legion Hall on San-Cap Road.

During the hurricane of 1926, the Reed home was destroyed. Its debris was used to rebuild a small post office, and that building is now part of the Sanibel Historical Museum and Village.

Webb Shanahan, son of the lighthouse keeper, rode a horse called Candy Kid to deliver mail. Later, he drove a Ford, one of the first on the island.

Scotia Bryant's house today on Ferry Road. *Photo by Manfred Strobel.*

William Reed retired in 1940, and for the next three years, his daughter Carrie took over.

In 1943, Scotia Bryant became postmaster. She moved into the small home built by the Kinzies after the post office was relocated to Ferry Road. The boat continued to land at Bailey's dock, so Bryant had to walk along the shore of the bay to take the mail to the new post office. She learned to decipher the bad, scratchy addresses on the envelopes so well that locals often asked her to interpret letters they'd received.

When she first began handling mail, there were seventy-five year-round residents. In 1954, a larger office was built to handle the island's increased population. Overwhelmed with deliveries, Bryant asked for an assistant. Patrick Murphy transferred from a postal position up north and took over the delivery route from Bryant.

For mosquito protection, he wore a long-sleeved shirt, a net around his head and pants tucked into his socks. With true island spirit, he picked up milk, flour or a couple of gallons of kerosene for housebound customers. When delivering a package marked perishable, if the recipient wasn't home, he went inside and placed the item in the icebox. Murphy and his wife, Priscilla, later started a real estate business on the island.

Scotia Bryant retired in 1967 when a larger office was built on Tarpon Bay Road and Periwinkle Place, next to the Old House Shoppe. This building morphed into a restaurant in 1979 following the construction of a new office. Bryant's home, still a private residence, is a historical landmark on Ferry Road.

Casa Marina (#4)

The Bryants were one of the original pioneer families on Captiva. Their daughter Rosa operated a restaurant in Fort Myers, so when Ernest Kinzie built a small tearoom at Ferry Landing, he asked Rosa and her daughter Scotia to run it. Named Casa Marina, they served sandwiches, cold meat platters and soft drinks for lunch.

The restaurant's refrigerator needed to be lit because electricity wasn't available until World War II. Drinks were never very cold, and food couldn't be saved. Many nights, the Bryants invited all their friends to eat leftovers. Once the Coast Guard took over the lighthouse, the residents were able to get an electric refrigerator by signing a list. Scotia and her mother, comfortable with the leisurely pace of the island, never were interested in making a request. Frustrated by the lack of cool drinks at the café, one of their customers gave them a new refrigerator.

In 1954, hospital dietician Evelyn Pearson visited her friend Betty Sears, whose family owned a business and lived on Sanibel. Ernest Kinzie persuaded the women to take over managing Casa Marina. They expanded the menu and offered a range of food, from a peanut butter sandwich for $0.25 to a full-course dinner for $2.50. The success of the restaurant led the women to open the Nutmeg house on West Gulf Drive.

At that time, Casa Marina had the island's only public telephone, and locals fondly remember swatting swarms of mosquitoes while waiting to make a call. For many years, the Episcopal congregation worshipped in the tearoom before St. Michael's Church was built in 1961. A modified version of the original building is visible at the end of the road.

Ferry Road is still a shady lane with tall vegetation and quaint island homes—a wonderful place to remember the past and enjoy the present.

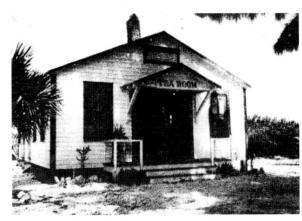

Casa Marina Restaurant circa 1930s. *Courtesy Sanibel Public Library.*

Chapter 3

COMMERCE COMES
TO THE ISLANDS

Living and Working at the East End

At the eastern tip of Sanibel, a quaint little village replete with clapboard buildings, fishing pier and lighthouse served as a hub of activity from the late 1930s until the mid-1950s. Dubbed "Old Town Sanibel" by island historian Elinore Dormer, early residents came to this area to dig wells and construct their homes because of its easy accessibility.

Houses, hotels and shops sprang up along the dusty path known as Periwinkle Way, which connected Ferry Road with the rest of the island. Pioneers traversed this bumpy road by foot, wagon or donkey to farm and trade. Today's remaining buildings are now part of the historic east end.

CHARLOTTE KINZIE'S COTTAGE (1950–TODAY) (#5)

In the early 1900s, Andrew Kinzie and his brother George started a steamship line in Fort Myers. Their ships were the only connection from the city to the barrier island. Andrew married Lotte Eyber, a resident of Captiva. Charlotte was the youngest of their three children, and the family lived on Jackson Street in Fort Myers.

Long before Sanibel had a ferry, Charlotte and her father took his steamer down the river delivering cargo and passengers. At that time, the only dock on Sanibel was at Matthews Wharf. During World War II, Charlotte served as a WAVE officer in the medical corps, and in 1949, after her father died, she returned to the family's home on Captiva.

Her brother Ernest was now in charge of the ferryboat business and Charlotte manned his office at Punta Rassa. She spoke about how the ferry office served as a chamber of commerce for Sanibel back then, promoting the island and the ferry service. "We were trying to build up a ferry business and develop some of the land over here, which no one would appreciate hearing about today." Though living in Fort Myers, she continued to spend time on Captiva in the family cottage. Because the ferry business was concentrated on the east end of Sanibel, Charlotte decided to sell this cottage and purchased one under construction on Sea Grape Lane. "It was the first house built between Bailey Road and Ferry Road, so you can imagine what the island was like," remembered Charlotte.

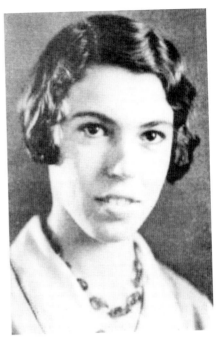

Charlotte Kinzie White as a young girl. *Courtesy Sanibel Public Library.*

Casa Blanca today. *Photo by Manfred Strobel.*

The Sea Grape cottage later became the nucleus for the Casa Blanca apartment complex, which she and husband Dwayne White, former mayor of Sanibel, constructed in 1968. They sold the development eight years later and built a home on Ferry Road.

THE SEAHORSE SHOPS AND COTTAGES (1954–TODAY) (#6)

In the early 1950s, Joe and Mary Gault moved from Detroit to Sanibel. With just $4,000 to spend, Joe and his father built a small shop, not far from the ferry landing, on Periwinkle Way. In her book about Sanibel and Captiva, Florence Fritz remembers the Seahorse Shops as "a most unusual little outdoor marketplace with a row of doors that folded back and left the entire front open to the feel and sound of trade winds and sea."

The Gaults wanted their shop to provide an outlet for the silver, enamel and shell jewelry that Joe designed. The location along the island's main road, coupled with a lack of competition, made the store a winner. Although the shop stayed open all year long, the island was not a tourist mecca. "We didn't take in an awful lot of money back then, but it didn't cost much to live," remembers Joe.

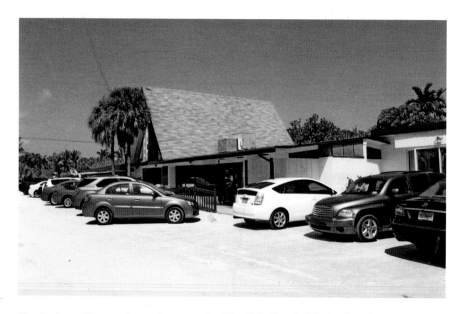

The Seahorse Shops today at the east end of Sanibel. *Photo by Manfred Strobel.*

In the beginning, they joined a business community that included the old Bailey's Store, a gift shop, a few motels and resorts and a modest restaurant. Some of their esteemed customers included Thornton Wilder and the Countess Tolstoy. "We used to be able to sit in the shop and tell who was driving by, just by the sound of their cars." When the Gaults went out to lunch, they left the shop open with a sign that read, "Take what you want and leave the money." And people complied. Joe and Mary sold the shop in the 1970s.

Site of the Cuban Fisheries (Area Alongside Seahorse Shops) (#7)

Beginning in the 1690s, Cuban fishermen traveled to San Carlos Bay to harvest mullet. Many of the vessels were guided by Calusa Indian refugees familiar with the area. Terevo Padilla built fish camps or "ranchos" on Sanibel and Captiva after he saw future wealth in the grassy bays and inlets. In season, the mullet ran in enormous schools that looked like living, moving islands and were noisy enough, especially at night, to awaken the soundest sleeper.

Padilla lived in Cuba and Key West before bringing his family to La Costa Island, north of Captiva. His ranchos operated from October to February, when the mullet were fat with roe. Each consisted of about twenty-five men supervised by a foreman. The Sanibel fishery was located on the harbor near the site of today's Seahorse Shops alongside an old well that probably served the settlers and seafarers for hundreds of years.

Palmetto-thatched cooking and working sheds were built, as well as a warehouse and quarters for the fishermen. There was little if any gardening, but everyone ate well. Wild guavas and hearts of palm were there for the taking, and the men cooked fish, birds and gopher turtles over large pots of burning charcoal. Pompano, turtle and sea trout were dried and salted for transport.

The fisheries closed down in the early 1880s when Americans arrived, chasing the Cubans away. But smacks continued to fish the snapper and grouper holes miles off shore and were a common sight laying at anchor in San Carlos Bay well into the 1960s.

During the pioneer farming years, Cubans slipped ashore to trade rum for delicious tomatoes. At first, northerners were afraid when knife-wielding sailors roamed the islands. However, their concerns ended after a couple of friendly confrontations. Such an encounter took place when a group

stopped at a dwelling at Point Ybel. The islanders and fishermen were at a disadvantage, since neither spoke the other's language. To get their point across, the Cubans gestured wildly with their hands, wanting something. The islanders, still a little fearful, didn't understand until one of the fishermen drew a picture of a pair of scissors on the sand. The man wanted to borrow a pair of scissors to cut the hair of the men on the fishing smack. The farmer lent his scissors, and the sailors departed. Later that day, they returned the scissors and brought a freshly caught fish as a gift. They filleted it and gave it to the islanders.

During times of social and political unrest, as in the Seminole Wars, the ranchos were attacked and/or abandoned, but they reestablished themselves once peace was made. However, after the Second Seminole War, the U.S. government adopted a policy of non-settlement in the region. While some fishermen moved their ranchos north to Tampa, other Cubans, farmers and Indians who had intermarried relocated west.

CASTOR BEAN FARM (#8)

The need for castor beans also drew farmers to the area. Yellow fever had killed hundreds of Union soldiers and Confederate prisoners. Treatment for this disease was castor oil, but the amount needed was enormous and created a demand for castor beans, easily grown on Sanibel.

For this reason, William Smith Allen sailed from Key West to Point Ybel in 1868. Allen did so well with his farm that others flocked to the area and set up their own plantations. But after a disastrous hurricane destroyed the island in 1872, farmers salvaged their crops and returned to Key West.

As today's visitors flock to the islands, the east end still remains a small epicenter for the islands, serving as a historically significant tourist attraction with easy access to the beach and the fishing pier.

BRIDGING THE PAST

Lindgren Boulevard to Bailey Road

There's an old saying on Sanibel that makes visitors laugh: once someone moves to the island, the first thing they want to do is blow up the bridge. Islanders have always had a love-hate relationship with their connection to the mainland.

During the 1950s, lines of cars stretched more than a mile down Periwinkle Way waiting to board a ferry that could carry only twenty vehicles. This forced day-trippers to wait for the next one. When wildfires devastated the island in 1955 because firefighters had poor access from the mainland, the Lee County commissioners reluctantly ordered a study to build a bridge. After spending $33,000 on an engineering analysis, the idea was scrapped when critics raised concerns that tolls would never cover the cost.

It took a man born in a farming community in Sweden to appease the skeptics.

THE SANIBEL CAUSEWAY AND BRIDGE (#9)

In the late 1950s, Hugo Lindgren bought a Gulf-to-bay parcel on Sanibel to develop homesites. However, potential buyers didn't have easy access, so he proposed a bridge from Punta Rassa to the island, terminating at Bailey Road.

Lindgren tempted the Lee County commissioners by promising to underwrite the preliminary cost. He offered a no-obligation deal, which asked for repayment only if sufficient bonds were not sold. The anticipated cost was $4.7 million, with an estimate that five hundred cars would cross the

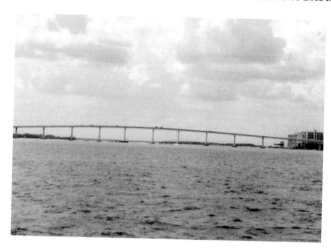

The Sanibel Bridge
and Causeway today.
Photo by the author.

bridge daily. No one ever imagined that forty years later, more than twelve thousand vehicles would traverse the span during a season.

The bridge was controversial, both on and off the island. Willis Combs, conservationist and leader of the opposition, is quoted as saying, "It's like an illegitimate baby—it's here and we have to take care of it."

Combs's organization raised $7,000 and sent a petition with six hundred signatures to county and state officials in an attempt to kill the effort. He recalls the final hearing: "When we were defeated for the last time at the Lee County Courthouse the police had to be called. We were radical demonstrators at the time."

Other opposition groups took their cause to the Florida Supreme Court—only to lose. However, many islanders approved because driving to the mainland would be easier. Charlotte Kinzie White wrote, "It was inevitable...the size of the ferries could no longer accommodate demand for service. Of course we had explored bringing larger ferries, but it meant a one-hundred-thousand dollar investment."

The United States Fish and Wildlife Service warned of the bridge's impact on the natural environment, but the concerns of the Lee County government were wholly commercial. They saw more tax dollars if Sanibel's popularity grew and more people moved to the island.

The county then recommended that the roadway be entirely supported by pilings, but the idea was rejected as being too expensive. The plan ultimately adopted provided for three connecting bridges and the dredging of the bay bottom to create two causeway islands in shallow water areas.

Completed in 1963, the causeway cost $5 million and paid for itself many times over with the $3 toll.

WHO WAS HUGO LINDGREN?

Lindgren, the son of a blacksmith, left Sweden at nineteen and came to New York seeking a better life. He found work in a furniture factory and later owned his own business, Jamestown Metal Products, which focused on building high-quality metal kitchen cabinets. During World War II, metal residential kitchen cabinets, sinks and stainless steel countertops were popular. Lindgren sold the business and came to Florida seeking other opportunities.

Extremely proud of the completion of the bridge, he's quoted as saying, "Can you imagine the thousands of tourists who would never have seen Sanibel, the hundreds of homes that would never have been built if it hadn't been for the bridge?" Those opposed to the structure argued against these same tourists, preferring the idyllic and isolated life of the past.

Instead of the bridge terminating at Point Ybel, the shortest route, it was extended 1,500 feet longer and ended on Lindgren's property because the bay was shallower there and cost less to fill. He also gave Lee County right of way through his property—now Causeway Road—when Francis Bailey wouldn't allow access through Bailey Road. Some characterized Lindgren as money hungry and unconcerned about keeping the beauty of the islands.

He was so unpopular with the residents that he continued to live in Fort Myers. Lindgren always maintained that he lost money on his investment. The building of the causeway and bridge led to ambitious plans by the county to develop Sanibel into an island of ninety thousand residents. With this catalyst, it wasn't long before islanders demanded incorporation—a move that ultimately blocked rampant development a decade later.

Islander Bob Sabatino was a $1.25 an hour laborer on the causeway. Now in his seventies, he recalls that wage as good money in 1962 when gas was $0.19 a gallon and $0.20 bought a loaf of bread. Afterward, Sabatino was sorry he hadn't applied to be a carpenter. "They made $1.75 an hour, and all they had to know was how to swing a hammer and make concrete forms." He was promoted to carpenter but didn't last long: "I kept dropping the wood in the water. I had to walk across the beams carrying big sheets of plywood. Every time a gust of wind came, the wood went flying into the water. The men in the boats below had to keep picking them up." After a few more incidents, he was demoted to day laborer.

Sabatino always doubted the long-term worthiness of the bridge. "The reinforcing bars in the concrete were already rusty."

The bridge was cheaper than the ferry. Compared to $1.50 for car and driver each way, plus $0.50 more for passengers, the $3.00 toll was a bargain. The price remained the same for forty years.

On the day of the dedication, only islanders Floyd and Gerald Snook were invited to attend, as perhaps an afterthought. They didn't receive their invitations until the day before and were stuck in the bleachers, rather than seated with the dignitaries. One local journalist wrote, "Our staff is beginning to understand how the 'underprivileged people' of the world felt when the missionaries arrived."

By the late 1990s, the bridge and causeway were considered unsafe. The constant backup of traffic when the bridge was raised and the lack of maintenance brought the issue to a head in early 2000. The Save Our Bridge Committee on the island demanded the county honor its agreement and maintain the bridge, rather than replace the structure. The group lost after costing islanders thousands of dollars in court fees, and the new causeway was built at ten times the original estimate.

JANE MATTHEWS WHARF (1896–1926) (#10)

Islanders continued to press for a wharf on the Lighthouse Reservation end of the island in the late 1800s. In January 1895, Frank Bailey wrote the Lighthouse Board (LHB) requesting a road, wharf and warehouse be built. LHB denied the request. That rejection didn't stop the residents from building a wharf in a cove next to where the current causeway comes onto the island.

A year later, a lighthouse inspector arrived and reported "that a road had been built across the reservation and that a Mrs. J.V. Matthews had constructed a wharf and warehouses on the northwest section without authority." A rich widow from Peewee Valley, Kentucky, she had come to

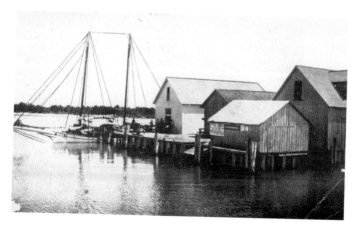

Jane Matthews Wharf before it was destroyed in the 1926 hurricane. *Courtesy Sanibel Public Library.*

homestead on Sanibel. Known to islanders as "Aunt Jane," she lived with Hallie and Will Matthews—no relation.

Because of her love of the island, Aunt Jane dedicated the dock for public use. The spot selected was the only deep-water place on the bay where a road could be built without mangrove interference. One wharf with three warehouses and one store was used for the steamers to land passengers and freight. In addition, there was a less significant wharf for little boats, a warehouse on shore at the high-water mark and a garage and small gasoline station.

To the trustees and their heirs, she gave lifetime rights to the two docks known as "Matthews Dock." They managed the wharf and plantation store for two years before selling them to J.W. Geraty. A few years later, Geraty sold the wharf and store to Frank and Ernest Bailey. These combined businesses of store, groves and gardens became the Sanibel Packing Company. About the same time, LHB deeded the strip to the residents of Sanibel and made the deal legal.

The Sanibel Packing Company proved the most durable of all island businesses, and the wharf served the island until 1926, when the store and all its businesses were destroyed in a hurricane.

The Bailey Home—The Teapot (#12)

The house was originally built in 1896 as a hip-roof square for fifty dollars. After Frank Bailey's marriage to Anne Matthews in 1919, they had three children, John, Francis and Sam, so the house was added onto in every direction. When it was finished, vegetation was so sparse that the Gulf of Mexico was visible from the front yard.

Bailey home, "the teapot," today. *Photo by Manfred Strobel.*

WHO WERE THE BAILEYS?

Ernest Royal Bailey arrived on Sanibel in May 1894 to investigate the feasibility of farming. Because the family's tobacco business in Covington, Kentucky, had failed, he decided to try farming citrus trees and leased a six-acre field. Touting the soil as excellent, he sent for his mother, Mary, and two brothers, Frank and Harry. Sanibel was a very different way of life for Mary and her sons. Instead of luxuries and society parties, they found dust and mosquitoes. Undaunted, the family made the island their home. Mary brought along a fine, high-wheeled buggy, fancy clothes and expensive dishes and glasses. With Hallie Matthew and Laetitia Nutt, she led Sanibel's genteel southern society until she died in 1913. The family was well received on Sanibel, and there were few civic or social affairs that didn't include one or all of them. Harry, easygoing and convivial, was a secretary before turning farmer. He married in 1919 and moved to Fort Myers. Ernest was an active layman of the Episcopal church. This confirmed bachelor loved acting in the theater.

At that time, Frank was a clerk in a steel rolling mill in Cincinnati, across the Ohio River from Covington. A genial man with a sense of humor, he was dependable, hardworking and the most responsible of the brothers. Founder of the Sanibel Community Church, he became a school trustee and justice of the peace. For the Baileys, the early years on Sanibel had many setbacks. The "great freeze" destroyed their first garden, as snowflakes drifted through the air and long icicles hung from the wooden cisterns. They replanted and were doing well by 1898. By 1926, Frank had married Anne Meade Matthews, whose family owned the Matthews Hotel. After Anne's death in 1935, Frank raised his three boys alone while continuing to run the old store with Ernest. Frank died in 1952.

SITE OF THE RUTLAND HOUSE (#11)

Named for Clarence Rutland, who lived in it from 1928 until 1982, the land was first homesteaded by Reverend Andrew Wiren and his wife, Abia. Wiren was a Lutheran minister of New Sweden, Maine, and he, his wife and five children arrived in 1884. In poor health, he died in 1890 and is buried on this site. Abia completed the homestead requirements and returned to Maine, eventually selling the property.

W.D. Swint bought a piece of the property in 1913 and built the house. Swint became a successful farmer growing tomatoes and peppers.

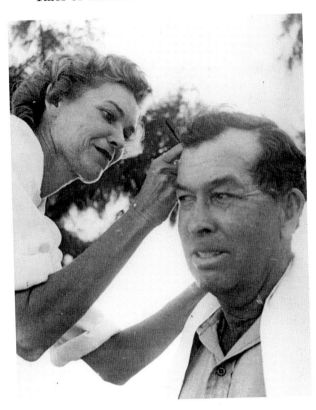

Clarence Rutland gets
a haircut from his niece
Snookie Williams.
*Courtesy Sanibel Public
Library.*

Clarence Rutland, who earned seven cents per crate packing tomatoes and peppers for Swint and other farmers, bought out Swint with a loan from Frank Bailey, who generously forgave payments from time to time. This original house is now part of the Sanibel Historical Museum and Village on Dunlop Road.

FIRST HOMES ON THE BAY
Woodring Point

Because of the navigability and protection this small harbor ensured, many seafarers like William H. Mackie, Captain Samuel Ellis and Commodore Edwin Reed built homes and farmed the fertile land.

FIRST HOMESTEADERS

William Mackie owned eighty-one acres stretching along San Carlos Bay, north to Bailey Road. He was known for weaving tall tales about his swashbuckling days running slaves. His stories described fighting natives on the beaches of North Africa, where he'd face death trying to pick up his cargo. Unable to endure the hardships of the island, he and his wife returned to Key West after receiving his homestead certificate in 1896.

Captain Samuel Ellis, a retired British navy sailor, came to the island with his new wife, Safiah Underhill, and her son George in 1891 to homestead 160 acres on the southern shore of Tarpon Bay.

Ellis spent little time farming, preferring to sail around the bay drinking from a large jug of booze, while back at the palm-thatched homestead, his wife did all the work. Safiah Ellis, of Indian ancestry, was wise in tribal lore and a competent midwife. Once she delivered a baby and insisted that the young mother swallow a potion made from deer horn, scraped from an ancient and dusty relic on the homestead's porch.

Smithsonian anthropologist Frank Cushing visited the Ellises in 1895 after he learned that Samuel had discovered some human bones in his garden. Cushing wanted to investigate and describes his visit as follows:

> *The mound was under cultivation as a vegetable and fruit garden…in an attempt to remove roots from a large stump…Captain Ellis made the find of human bones…in excavating nearby, I found that the whole heap was permeated…with broken human remains; large bones and small, many… had been split and shattered, mingled with skulls…I succeeded in securing eleven of these skulls before leaving.*

After the death of Captain Ellis, his widow divided the property with her son, George, who had brought his wife and family to the island. Safiah was buried on their homestead next to her husband.

Commodore Edwin Reed, a retired navy officer who arrived in the area at the same time as Ellis, homesteaded on the western shore of Tarpon Bay. Commodore Creek, leading to the bay, is named after the Reed homesite. His descendants continue to live in the area.

WOODRING HOMESTEAD (#13)

Sanibel Island's wild, untouched beauty fascinated itinerant blacksmith Samuel Woodring and his wife, Anna, when they explored the area in their sailboat in the late 1880s. A piece of land jutting from the northern end of the island was of particular interest to the couple. They vowed to return.

When the land was released for homesteading, Samuel claimed 160 acres of today's Woodring Point and, in 1888, built a large wood-frame house. A year later, he and Anna welcomed their second child, Flora. Records show that she was the first white child born on the island.

In an effort to survive and care for her family after Samuel's death in 1899, Anna, renowned for her culinary skills, took in boarders from the north. Flora helped her mother run this first hotel on the island by caring for the guests while her brothers, Sam and Harrison, spent their days fishing for food. Between all the fish, vegetables and chickens from the farm, the Woodrings and their guests had plenty to eat. Living on the water, however, had its drawbacks.

Flora remembers a near disaster during the hurricane of 1910. She and her sister-in-law were alone in the house caring for her two nieces. Accustomed to bad storms, neither woman gave much thought to the weather until they

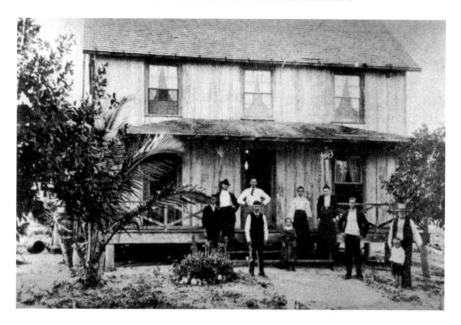

The original Woodring homestead, with members of the family shown on the right. *Courtesy Sanibel Public Library.*

noticed that all the water had been sucked out of San Carlos Bay. Flora, afraid they wouldn't survive the night, evacuated everyone to the newly built Clubhouse next door. When the water rushed back into the bay the next morning, the Woodring home was destroyed, but the women and children were safe. The home was later rebuilt, this time with more attention to withstanding storms.

After Flora married John Morris and moved to Fort Myers, Anna closed the boardinghouse and joined them. Flora's brother Sam and his wife, Esperanza, took over the homestead and started a fishing guide business. Sam Woodring Jr. met the fiery Esperanza while visiting Punta Gorda on a fishing charter. She was a descendant of Trevor Padilla, a Cuban fisherman who had arrived years earlier and started a number of fishing camps on Sanibel and other islands on San Carlos Bay. The couple's fishing expertise was so popular with rich tourists from the North that many built second homes on Tarpon Bay in order to spend their winter vacations fishing with their favorite guides.

Sam, a local character, had quite a reputation as a bootlegger because of a large still located in the interior of the island. Sam would craftily hide his finished product in the cool waters of Tarpon Bay, convinced that it was safe from poachers. However, the residents of Pine Island, familiar with the

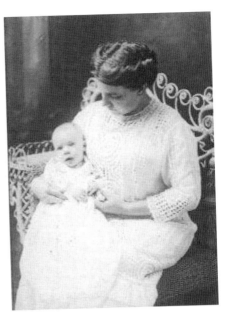

Flora Sanibel Morris, the first white child born on Sanibel, with her three-month-old son, Robert. *Courtesy of Robert Morris Family.*

Esperanza and Sam Woodring took over the homestead after Anna moved to Fort Myers. *Courtesy Sanibel Public Library.*

quality of Sam's stash, would sneak over in the middle of the night and try to steal the liquor. The sounds of shotgun blasts were not uncommon during these times. Tough drinking Sam wasn't about to let anyone leave Tarpon Bay with his booze.

Harrison, Sam's younger brother, worked for the Punta Gorda Fish Company and lived in a small fish house on the bay. Lacking good roads, water transportation was the fastest way to move around the island. Tourists and locals arrived by boat, bought their fresh fish from Harrison and then took it home.

A guide for more than sixty years, Esperanza never grew tired of spending lazy days on a boat. She claims that the fish houses on the bay would drip so much blood into the water that black tip sharks flocked to the area, giving locals another food source.

Esperanza often bemoaned the change in the water quality of the bay since her childhood. Red tide, wake from the boats and mosquito control channels, along with drainage dumped from the island into the bay, made a difference in the amount of fish, scallops and shrimp found in the water.

In the late 1960s a large corporation had plans to fill in Tarpon Bay for a housing subdivision. The locals furiously fought the idea, and fortunately for the bay, the city incorporated in the early 1970s before the development could be finalized.

Esperanza tells many stories about rearing children on Tarpon Bay. Originally, there was a marina on the bay called Dewey's. Jake Stokes ran it, and his children went to school with the Woodrings. Often, the tide would be so high in the morning that Esperanza and Jake had to piggyback the smaller children to Periwinkle Way to meet the school bus.

THE CLUBHOUSE (#14)

Sanibel continued its allure for wealthy Americans into the early part of the twentieth century. Though living on the island was a hardship to many pioneers, visitors loved the warm weather, wildlife and abundant fish.

In 1908, the idea of building a large home on the bay was the brainchild of a group of fishermen from Ohio who wanted to be near their guide, Sam Woodring. They banded together, purchased the land and built the Clubhouse. It was perfect for these men as a vacation getaway from the cold North, as well as respite from their socially involved wives.

Sam Woodring took these anglers into Tarpon Bay or the Gulf for a day of fishing. Then, with a bucket of cleaned fish in tow, Esperanza set up a

A 1917 photo of the Clubhouse on Woodring Point. *Courtesy Sanibel Public Library.*

fire beside the house and whipped up some tasty dishes. The Clubhouse was so popular that the McCullough family, part of the original investors, bought up the rest of the shares and converted the house into their home. Renowned photographer Charlie McCullough still resides in this house.

A Paddle Boat, a Hotel and the First Church

Casa Ybel Road

This dirt thoroughfare linked the middle of the island with the Gulf. After the "great freeze" of 1894, word spread that land bordering the Caloosahatchee River, especially Fort Myers, had not been affected and was still excellent for farming. This area quickly became a popular destination for farmers.

The Riddles

The Riddles, who lived in the Orlando area, had lost everything and decided to relocate. At that time, the railroad extended to Punta Gorda, thus enabling farmers to ship produce to northern markets.

George Riddle came to the island with a high work ethic and by 1904 was so prosperous from selling vegetables that he ran a store on Tarpon Bay. His daughter Louise Riddle Waldron, in an interview for the *Sanibel-Captiva Islander*, talked about life on the farm: "I used to be good at packing the tomatoes to New York. We used to wrap each one in tissue before we packed them."

The family owned two cows to keep their children nourished. Louise did the milking and butter churning. In 1902, Riddle donated a parcel of his property on Periwinkle Way so that the White Schoolhouse could be relocated. Their homestead would have been situated where Sanibel Highlands is located today. As a school trustee and Lee County commissioner, Riddle was required to do a fair amount of traveling.

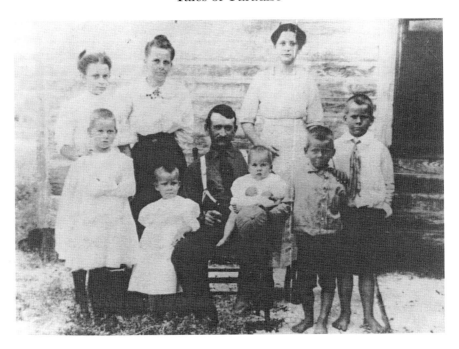

The Riddle family homesteaded along Casa Ybel Road in 1904. *Courtesy Sanibel Public Library.*

To guarantee enough food for his family while away, he dug a large pit under the kitchen floor. It was filled with sawdust and served as a receptacle for an immense chunk of ice brought each week from the dock at Matthews Wharf. Each winter, itinerant farmers traveled from New York State to work on this highly productive farm.

Almost every day, Mrs. Riddle and her children searched for shells on the beach in front of the Casa Ybel Resort. Often, guests would be the recipients of any rare finds. Mosquitoes were at their worst when sea grapes became ripe, so Mrs. Riddle armed each child with a smudge pot as they picked the plentiful grapes she later turned into jelly.

After the 1910 hurricane, the entire island was under water, with houses blown off their foundations. The Riddles took refuge in their own sturdy packinghouse and stowed the youngsters in the vegetable sorting bins. The aftermath of the storm was a layer of salt that burned all the vegetables. Riddle tried for four years to wash his vegetables. He finally hired Captain George Cooper's passenger freighter to transport his family, household possessions and livestock upriver to Fort Myers.

THE JORDANS

Carl and Mozella Jordan lived in a house on Wulfert Road from the 1950s until the late 1960s. Realizing a dream, they purchased a home on Old Taylor Road just off Casa Ybel in 1969, making them the first black couple to own land on the island in their own name. Mozella remained there until her death in 2007.

Carl, the grandson of early pioneers Harry and Pearl Walker, was the first black child born on Sanibel in 1932. He spent his early childhood summers collecting shells on the beach and selling them to tourists. In an interview for a local paper, Carl recalls earning one dollar per bushel for the more common shells and eight dollars for the rare pectins. As a young boy, he helped with farming chores. He remained on Sanibel until his death in 2005.

Mozella arrived on Sanibel in the late 1940s. Carl worked as a handyman, electrician and master carpenter, and the couple met while they were both employed at Casa Ybel Resort. Under the direction of the head chef, Mozella mastered the culinary skills that led to her career in catering. Carl often cooked on Fridays when the resort held its buffets on the beach. Their son Tim was the first black child baptized on Sanibel in the 1960s.

THE *ALGIERS* PADDLEBOAT (#15)

In the late 1950s, Helen Brown, a shell enthusiast and a member of the social register in San Francisco, visited Sanibel Island with her husband, Lathrop, a gun enthusiast. He was looking for a spot to set up a proper range for skeet shooting and found acreage in what is now known as the Rocks subdivision. The former New York State congressman and best man to Franklin Roosevelt was known as an eccentric.

Mrs. Brown fell in love with the area and was searching for beachfront property when she heard about an auction in New Orleans. She flew to Louisiana and bought the SS *Algiers*. The boat was a ferry that transported cars, people and freight from one side of the Mississippi to the other. It was a twin-screw, coal-burning steamer with a double-catamaran hull type including two decks and a pilothouse. It measured 150 feet long, 67 feet wide and had a draft of 7 feet. Unable to maneuver under its own steam— the operating machinery had been removed—two tugboats were hired to bring the boat to a final resting place on Sanibel. It took almost two years to complete the renovation in Fort Myers.

After the boat was finished, it had six master bedrooms and five and a half baths, plus a servant's room and bath. Some of the baths had French marble

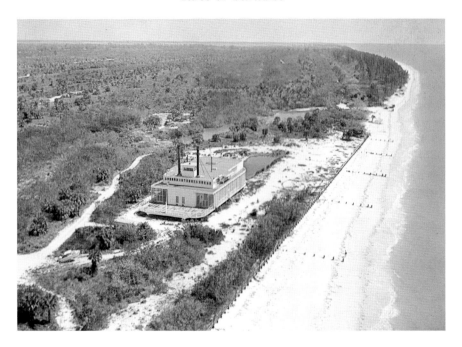

The *Algiers* paddleboat. *Courtesy Sanibel Public Library.*

lavatories with gold-plated fittings and built-in electric heaters. The den had a wood-burning fireplace, and the kitchen was equipped with six ovens and a six-burner gas range. It also boasted a large refrigerator and freezer with icemaker, disposal and dishwasher.

Mrs. Brown continued to look for land on Sanibel, when finally a piece along the Gulf caught her eye. It was thirty acres with a pond and a one-thousand-foot strip along the shore. There was only one problem—how to get the boat onto dry land.

An L-shaped canal was dug from the Gulf to the pond. Two tugs carefully inched the 150-foot paddleboat into its dry dock and filled in the canal. After the boat was placed on land, the Browns moved into an upstairs bedroom to wait for the project to be finished. A month before completion, Lathrop Brown was stricken with a ruptured gall bladder and died at age seventy-six. Helen, inconsolable, left the island and never returned. The mansion was destined to sit empty and mysterious for twenty-three years. Its feathered stacks, used by boaters as a landmark, were watched over by a succession of caretakers.

Bill Shore worked there for nine years. Shore started visiting the island in 1960 and was always curious about the boat. In those days, trees were not so tall, and the smokestacks were visible from everywhere. He lived in a

Beach at Algiers Park today. *Photo by Manfred Strobel.*

tiny house trailer near the boat before being given permission to move into one of the upstairs bedrooms. He claims he spent about one hundred hours a month on maintenance—repairing the fence, mowing and painting. He was not a watchman but owned a gun, used to scare people away. Shore carried his .25-caliber pistol in a shoulder holster, but it kept falling out. "It's a wonder I never was shot. It was real pretty on the boat on a moonlight night. Sometimes I just sat on top and watched the stars."

After Mrs. Brown died, the *Algiers* and surrounding land were put up for sale. The City of Sanibel purchased the property for $1.3 million. Initially, the thought was to try and convert the boat, but, now unsafe, it was too expensive to save and was bulldozed in 1982. Before being destroyed, its furnishings were auctioned off to the more than one thousand people who gathered to see the paddleboat for the last time.

Its acreage is now Gulfside Park. Today, the park serves as a picnic area and beach access for island residents and visitors. Residents still talk about this Mississippi paddleboat with the golden faucets—maybe the first mansion on Sanibel.

CASA YBEL RESORT/THE SISTERS (#16)

Ohio preacher George Barnes, an evangelist of great eloquence and power, portrayed Sanibel to his followers as the Promised Land. A tall, handsome man, he cast a spell over his congregation, yet none doubted his Christian

commitment. Because of his proselytizing in backwoods Kentucky, the *Louisville Courier-Journal* called him the Mountain Evangelist and printed one of his sermons every day. At the height of his career, thousands flocked to hear him.

As Barnes's eyesight began to fail, his daughter Marie read the scriptures to the faithful. Eventually, he took his crusade across the United States, and in 1883, he made a successful world tour. Six years later, he was invited to speak in Punta Gorda. The family was cruising with friends aboard a sloop when it went aground in San Carlos Bay. The passengers decided to explore a nearby island—Sanibel—to pass the time until the tide changed. Excited by its pristine beauty, Barnes inquired about homesteading. That year, he, his wife and their three children—Marie, Georgia and Will—each claimed a 160-acre tract on the Gulf. The preacher believed that God had brought him to this paradise.

At first, the Barneses lived in the middle of their property in a house called Palm Ranch. It was a small stilt dwelling with a porch leading to the front door accessed by a ladder-like stairway that must have been difficult to climb for women in long dresses. In 1890, they constructed a cottage hotel at the junction of land owned by Marie and Georgia and called it the Sisters. It became a popular resort for wealthy northerners, many of whom were the preacher's followers.

Georgia married Edward Duncan, a guest from Kentucky, and the newlyweds built a house next door to the hotel. Known as the Thistle Lodge because of the wild purple thistles that grew on the site, the home was remarkable for its size and four prominent turrets and was often the subject of numerous articles in the local papers.

In November 1896, the *Fort Myers Press* indicated that "the Hon. E.M. Duncan's palatial residence on the Grand Boulevard is nearing completion."

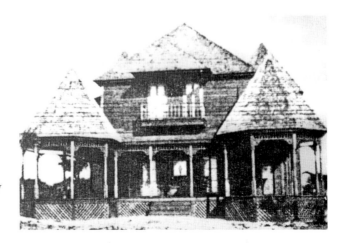

Casa Ybel in the early 1900s, as the Sisters. *Courtesy Sanibel Public Library.*

The article went on to describe the Grand Boulevard on Sunday afternoons: "A parade ground with handsome turnouts, spirited horses, and beautiful ladies. The ladies dressed in their full finery—long skirts reaching the ground, full-length sleeves, with these hot 'neck chokers' and wore huge hats decorated with sea shells, sea grasses, urchins and other things washed up on the beach."

Being a man of the cloth, Barnes's real goal was to build a church on the property so that visitors and islanders could worship together. His nondenominational Church of the Four Gospels was constructed in memory of his grandson, who was born and died in 1893. Barnes made sure that the cross on the roof rose high into the sky, hoping that it would attract and encourage seamen sailing down the coast.

Jane Barnes spent hours teaching and singing to the island children while the Reverend Barnes told stories and made candy. Once, he drove along the shore with a wagon full of children singing Christmas carols.

The evangelist was also a successful businessman and, along with his son Will and son-in-law Edward Duncan, filed papers in 1897 with the Florida legislature to establish the Sanibel Island Railway and Construction Company. According to the documents, "The purpose was to build, equip, operate and maintain a line of railway from a point known as Reed's landing on the shore…to the extreme western end of Sanibel Island with all necessary branches and side tracks." This would have been an excellent alternative to roads that were almost impassable or often under water. Unfortunately, Barnes's dream never came true. His wife died suddenly in 1901, and the grief-stricken preacher fled the island.

Daughter Marie was intrigued by evangelist Aimee McPherson and moved to California. Her sister Georgia soon joined her. Their brother Will was widowed young, married again and took over managing the hotel, renamed Casa Ybel, at the turn of the century. He died in 1923, and Charlie Knapp bought the property, which included a dozen buildings and 306 acres of land, a mile and a quarter of which was Gulf beach. He paid $19,000 and sold it in 1945 to Dayton Hotels, which sold it to Mariner Properties for $2.4 million in 1977.

During World War II, gunnery crews and planes practiced over the Gulf and flew day and night. Two cottages in the rear of the resort were renovated into quarters for the military on duty. Stationary practice targets were set up on the beach for low-flying planes, and sentries were placed along the road to warn islanders.

A plane of trainees once flew low over where fishermen were working and began shooting. The plane crashed into the water and ended up tearing off the end of the boat. Everyone landed in the water, but only the pilot and the fishermen lived. Charlie Knapp picked up some boards for a raft and, with help from locals, brought the survivors to shore.

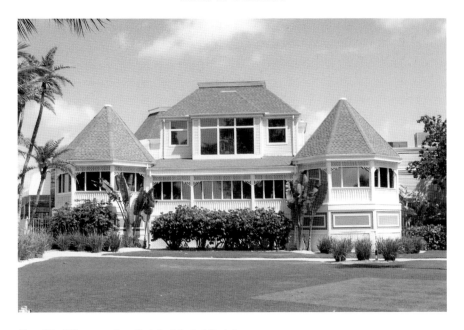

Casa Ybel Resort today. *Photo by Manfred Strobel.*

Many famous people spent time at the hotel during the early twentieth century. Thomas Edison came to the islands in search of tropical plants and natural rubber, while his wife, Mina, enjoyed shelling.

A custom at the resort was to use conch shells to call visitors to dinner. In the 1950s, flying in and landing on the beach was a common practice for winter tourists.

After Mariner Properties bought the resort, there was hope that the Thistle Lodge would be restored and preserved as a historic landmark. Sally Cist Glenn, who had lived there for many years, planned to move it to another location and renovate it for her family's use. However, the problems of getting permits were insurmountable, and the structure was demolished in 1978. The remaining buildings of the old Casa Ybel were removed, and in 1979, modern condominiums were built.

OLD SANIBEL CEMETERY (#17)

The Sanibel Cemetery, off Casa Ybel Road, is located on the original Barnes homestead. In 1900, the family donated the land to be used as a public burial ground. In 1975, Howard Dayton donated the eleven-acre tract to the city. Bike paths encircle the cemetery. The earliest graves date back to 1889,

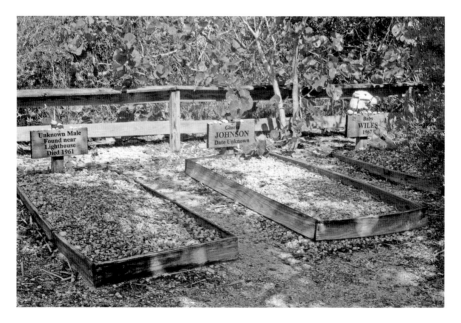

Graves at the Sanibel Cemetery today. *Photo by Manfred Strobel.*

when the wife and son of Captain Will Reed were buried. The stillborn daughter of George Riddle is also interred here.

When Reverend Barnes built the church, there was a cemetery alongside. It is believed that Jane Barnes was buried in 1901 beside her grandson, and George Barnes was buried in 1908. The 1910 hurricane demolished the church. After the property was sold in 1913, the family was reburied in Danville, Kentucky.

Eugene Reed drowned shortly after the family's arrival and is buried beside his parents in the cemetery. While Captain Reed, who died in 1921, has his grave marked at this cemetery, other sources say that his final resting place is Penobscot Bay, Maine.

Edmond Taylor, a shrimper and handyman, died in 1967 and was the last person to be buried in the cemetery. He was from New Jersey and had no family, so a small graveside service was performed by local residents. Today, the cemetery contains thirty-one graves, many unmarked, and is no longer used.

Many of the earliest arrivals are buried elsewhere. Spaniards and Indians who died on the island had their graves marked with seashells, all now lost. Some of the earliest homesteaders' graves are also lost. Othman Rutland, father of Clarence, lies buried on the grounds of his home on Periwinkle Way next to the retail shop She Sells Seashells.

ROAD THROUGH PARADISE

Periwinkle Way

Native Americans were also enticed by the island's abundance of fish, oysters and turtles. To access the entire island, they chose to travel the interior high ridges, clearing brush and tramping over scrub grass, thus leaving the path that could easily be traversed by the earliest pioneers. Named after the beautiful purple and white flowers blooming alongside, Periwinkle Way became a popular route to the ferries. Early residents took advantage of this and built businesses and erected community centers along this dirt thoroughfare.

It wasn't until the 1950s that the street finally received a layer of asphalt. Before that, residents bumped along in carts or rode on mules or in cars—never really caring about the inconvenience, just happy to be living in such a beautiful place.

The absence of a central place as a gathering area was a problem on this wild, untamed island, particularly after the disastrous hurricane of 1910. To solve this, land was donated along Periwinkle Way for the construction of another church. (Some of the pews from Barnes's demolished church are now part of this building.)

THE SANIBEL COMMUNITY CHURCH (#18)

Residents welcomed anyone bringing a religious message, whether an itinerant preacher or a circuit rider in a sailboat, or someone like missionary George Barnes. Attending services was often by boat over contentious seas, by horse and wagon or on footpaths where alligators crawled nearby.

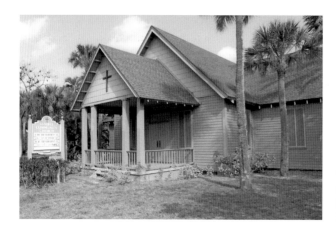

The Sanibel Community Church today. *Photo by Manfred Strobel.*

When the first permanent church was organized in June 1914, the majority of the farmers were Methodists. After the site was donated, members of the future congregation held cake sales and other activities to raise money. Construction of the building started in 1917. Materials were hauled on a mule-drawn wagon from the Wulfert boat landing, and all the labor was done by islanders.

Though services only took place once a month with a pastor coming from Fort Myers, Sunday school for all ages was held every week. By 1925, the church was out of debt, but the hurricane of 1926 forced most parishioners to move to the mainland, and Sunday services were held only when a minister was available.

The first Christmas remains a wonderful memory for those early parishioners. Frank Bailey read the Christmas story, and carols were sung, after which gifts for the children were given out at the schoolhouse. Mrs. Sydney Baldwin recalls the day:

> *Casa Ybel had one old seven-passenger automobile that only one of the servants could run. He loaded it up on Christmas Eve and took us all to the church where the island children sang…the air was soft and mild… and the door of the church stood open…and against the screen of the back door a tangle of morning glories…clung to the mesh…like a design on a stained glass window.*

In 1938, Reverend Linn, a Presbyterian missionary funded by the Board of National Missions for Florida, reopened the church and served as its minister until 1941. There are no known records to indicate who served the church after that, but in 1950, a Reverend Milligan presided until 1960, holding services year round. Five years later, parishioners discussed erecting a new church, but with only $400 in the treasury, more money was needed.

At the same time, a section of land adjoining the church was offered for a parking lot. But before this could happen, parishioners had to secure a legal charter and adopt bylaws. In 1959, the owners agreed to sell their property, and an offer was made to purchase the land and building for $7,500. The purchase was completed in 1960.

Thaddeus Allen was the first full-time resident minister, serving until 1970. During this time, the structure was painted and the Women's Guild paid for the installation of a bathroom. Members continued to make improvements and additions for meetings, dances and other activities, and today, the church still ministers to island residents and tourists.

BUZZARD'S ROOST (#20)

More than one hundred years ago, this small house was part of the 'Tween Waters Inn on Captiva and served as a home for area fishermen. The survivor of several hurricanes, the cottage, built of Dade County pine, was restored and has been the home of Buzz Murphy and Joanne Marriott since 1969. However, in 1974, it was almost destroyed to make room for a new

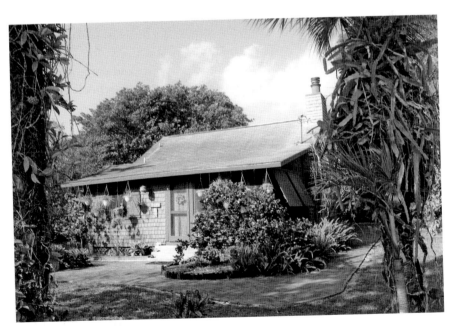

Buzzard's Roost was one of the original cabins at 'Tween Waters. *Photo by Manfred Strobel.*

building. Murphy was living in the place and wanted to keep it: "The owner kept asking me why I was always fixing stuff since the house was going to be torn down. I told him that's what I like to do, fix things that need it."

He convinced the owner to sell the cottage to him for $1 and made preparations for the move to Meridian Drive on Sanibel. With an electric saw and a little help, he broke the cottage into three parts and, at a cost of $3,900, had it trucked to its present location after approval by the Sanibel City Council. The house retains historical wood structures, such as the original wood storm shutters, tongue and groove wood floors and blown-glass windows with wood frames that slide. Most of the furniture is from the original cottage.

SITE OF THE OLD SCHOOLHOUSE (THE BUILDING IS NOW PART OF THE HISTORICAL VILLAGE) (#19)

In 1888, Sanibel boasted one hundred inhabitants and petitioned Lee County for a school. Two years later, the Board of Public Instruction decided that two schools would serve the needs of the residents: an east-end school on Periwinkle Way and a west-end school at Gray Gables on West Gulf Drive.

During the hurricane of 1893, the original building was blown down and another constructed in 1898 for $530 at the corner of Bailey Road and Periwinkle Way. After residents petitioned the school board, the structure was moved farther down the island in 1903. It finally closed in 1962 after a larger school was built on San-Cap Road.

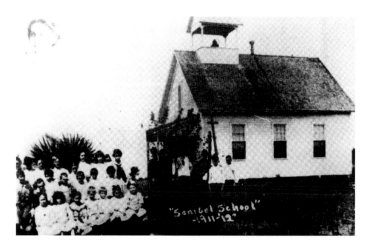

The Old Sanibel School, circa 1911. *Courtesy Sanibel Public Library.*

Ruth and Phillip Hunter, professional actors from the New York stage, bought the building a year later and ran it for eighteen years as a theater. They painted it pink, converted it to a ninety-seat theater arranged in two tiers surrounding a square stage and called it the Pirates' Playhouse. Ruth was renowned internationally for her role as Ellie May in *Tobacco Road*.

Dusty shells and starfish hung suspended in a fishing net draped across the curtained windows. The play always began with a scratched phonograph record playing the "Star-Spangled Banner." Just as the audience got to the "rockets' red glare," the needle jumped, leaving everybody half a bar behind. The Hunters specialized in staging one-act plays and little-known British comedies. Their first production was *The Reluctant Debutante*, and tickets were two dollars. Many well-known islanders, such as future CIA director Porter Goss, acted in the productions. It was such an intimate place that if the play were a mystery, audience members shouted clues to the detective.

Ruth and Phillip Hunter in their final season at the Pirate's Playhouse in 1981. *Courtesy Sanibel Public Library.*

Robert Troperzer and Carrie Lund kept theater alive on Sanibel in 1984 after the Hunters retired, producing three plays a year. After Lund and Troperzer parted company, the theater was sold again in 1988. The new owner made an arrangement with Carrie and her husband, Robert Cacioppo, to produce community theater. The most notable of their plays was one written by Mike Fury, *The Day They Blew Up the Bridge*.

In the late 1980s, there was a growing need for a larger theater, and with donations from islanders, the Cacioppos built across from the Sanibel Community House. Carrie Lund then invited J.T. Smith, who had written

and produced original cabarets in Captiva, to perform in one of the productions. When the little pink theater/schoolhouse was abandoned once again, Smith's supporters organized and loaned him enough capital to restart the theater, renaming it the Old Schoolhouse Theater.

In 2003, Smith became too ill to continue with the productions, and the theater was forced to close its doors. The following year, it was bought by the Historical Preservation Committee, which arranged to move the building to a site at the historical village on Dunlop Road. Once there, the old theater was restored to its original state as a one-room schoolhouse.

THE SANIBEL COMMUNITY HOUSE (#21)

Curtis Perry, a winter visitor from Maine, decided to organize the Sanibel Community Association. A bachelor who loved to paint sunrises and sunsets, he spent his winters at the Matthews Hotel and loved to walk the island, end to end, raising funds for a building to house the newly formed association.

In 1927, construction began on land donated by Cordelia Nutt. The wide, enclosed porch with a band of individual windows is a hallmark of this structure. The roof has a lower pitch than the building's gable, and brick chimneys mark each end of the meeting place, while the white clapboard siding and low ceilings are typical. The bylaws for the Sanibel Community

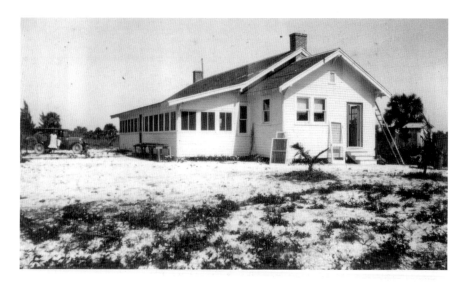

The Sanibel Community House in the process of being built in 1929. *Courtesy Sanibel Public Library.*

Association were written in 1928 with the following stated purpose: "The Sanibel Community Association is composed of neighbors joined to do what none could do alone." It has been the scene of annual shell fairs, housed the library and served as the chamber of commerce. Dances were held at the newly built Community House, along with plays and lectures.

The early years saw the emergence of many island supporters, most notably Captain R.C. Cockerill and his wife, Lillias. Captain Cockerill was the author of *Songs of the Gods*. He wrote and composed music and spoke in five Indian dialects. His wife, a British actress, had a wonderful sense of humor. They arrived on Sanibel in 1926, and the captain immediately started writing plays and songs that islanders delighted in performing. When there were still oil lamps in the building, Lillias and Ernest Bailey put on sketches to help raise money for electricity.

One of these memorable plays, *The Census Taker*, had famed locals like Clarence Rutland and Ernest Bailey performing comedy on the stage. Frank Bailey and Lillias Cockerill acted in a number of Shakespearean plays.

The Shell Fair

The Matthews Hotel had a custom of setting aside one day a year for guests to display their shell collections, and in 1927, it became an annual affair

The Sanibel Community House today. *Photo by Manfred Strobel.*

held at the Community House. Initially, only native shells were displayed, each arranged on cotton in a cardboard box, labeled with names like Scotch Bonnet, Chinese Alphabet and Lion's Paw. Shell craft, needlepoint and baked goods were sold, and the women served lunch. One year, Francis Bailey's chickens were displayed. Except for the years during World War II, the fair has been held annually.

The Sanibel Community Center even now remains a centerpiece of the island, offering classes and social activities.

THE NAVE HOMESTEAD (#23)

Al Nave was born in Bradenton, Florida, in 1927, and traveled to the islands for the first time with his mother and stepfather, Martin and Sadie Hiers, in 1939 to look for shells. Martin Heirs later bought property and built a home. Since Nave had recently gotten his plumber's license, he began working with his stepfather on a group of cottages on the beach, later known as Hiers by the Sea.

Nave saw a business opportunity when he realized that newcomers needed a good plumber. He and his wife, Goldie, decided to start Nave Plumbing in 1949 and purchased their property, Sanibel Square. Their first home, an A frame remains today the main structure for the children's shop in the square. Total cost of the structure was $500. They lived in the home for about a year with no electricity or water, adding more space as children arrived.

Back then, Nave Plumbing did everything for everyone: gutters, pumps and wells—anything that was needed. Many famous customers darkened their doorstep throughout the years, including Ding Darling, Kendall Gillette and Durwood Kirby. Nave also helped build the sets for the motion picture *Night Moves* with Gene Hackman, filmed at Woodring Point. There were no contracts, just word of mouth and a handshake.

According to an article written by Nave's longtime friend Roger Tabor for the *Island Sun*, "Times were simpler then, everyone knew each other, there were dances at Casa Ybel, fish fries on the causeway, and a real sense of community."

Chapter 8

THE SANIBEL HISTORICAL MUSEUM AND VILLAGE

Dunlop Road (#22)

In 1974, the City of Sanibel incorporated to halt the uncontrolled growth on the island. Troubled by the destruction of Sanibel's past, island historian Elinore Dormer helped form the Historical Preservation Committee. Mary Gault Bell, one of the original members, talks about the idea for a museum: "Ellie and I were sitting on Clarence Rutland's front porch shortly before his death, and Ellie thought the house would be perfect as a museum. She asked the city to buy the place, but it got too complicated. But she never gave up on her dream."

After Clarence died and the Muench family bought the property to expand their trailer park, the house was donated to the city. Public land was set aside for the museum, and somehow the committee raised the $3,500 needed to move the Rutland House to its present site.

Over the next few years, local islanders donated money and volunteered innumerable hours to locate and preserve maps and artifacts, as well as tape interviews with many of the remaining early settlers, like Esperanza Woodring, Flora Woodring Morris, the Bailey brothers and Charlotte Kinzie White. Their hope was to reconnect islanders to the now forgotten sounds of snapping whips and the toot of a whistle announcing the arrival of the ferry and the peaceful but difficult life of the first settlers.

On the city of Sanibel's tenth anniversary, November 10, 1984, the museum was opened, with Sam Bailey acting as docent. In 1991 and 1992, the Bailey family donated the old Bailey's Store; Miss Charlotta's Tea Room and the old post office and paid for the move from San Carlos Bay to sites at the historical village on Dunlop Road.

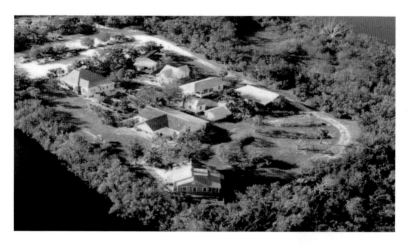

An aerial shot of the Sanibel Historical Museum and Village. *Photo by Jim Anderson.*

The additions of the Burnap Cottage and the Morning Glories House in 1998 and 2001 enhanced the village further. Finally, Sam Bailey got his wish when the old schoolhouse was moved in 2002.

The Sanibel Historical Museum and Village is a memorial to the hard work of so many.

THE RUTLAND HOUSE

This 1913 residence is a typical Florida cracker-style home (the word cracker derived from the sound the whips made when cattlemen snapped them) made of hard Florida pine. The building stands above ground on pilings composed of concrete and beach sand. This form of construction protects it from floods and allows air to circulate. The eleven-foot-ceilings, wide hallway and placement of windows and doors opposite each other promoted cross ventilation and kept the house cool. The donated furnishings inside are characteristic of Sanibel and Captiva in the 1930s and 1940s.

Ken Cox, nephew of Clarence Rutland, remembers spending summers on Sanibel. Ken's grandmother, Margaret, was Clarence's younger sister. "I remember visiting Uncle Clarence when I was a boy. We all sat outside on the porch, Uncle Clarence in a rocking chair. The walls inside the house were black from the soot of the kerosene pots used to keep out mosquitoes. I don't remember the ceilings being so high."

Ken's great-grandfather, Othman Rutland, came to the United States from Rutland County, England, in 1880 to work in the citrus groves in

The Rutland House at the historical village. *Photo by Manfred Strobel.*

central Florida. In 1884, he bought a grove, and he and his new wife, Irene, built a house in Apopka. Two years later, the "great freeze" wiped out the citrus industry. Othman moved his family farther south to Sanibel, where they scratched out a living by truck farming tomatoes. He died a year later, leaving his wife with five children. Irene then married Henry Shanahan, a widower with seven children. They combined their families, added one of their own and moved into the keeper's quarters at the Sanibel Lighthouse.

Clarence Rutland was a typical Sanibel pioneer. He tilled the soil, fished the bays, worked on cattle boats leaving Punta Rassa, drove a trolley in Tampa, ran a delivery service on the island and, in later life, became the island's handyman and contractor. Rutland also served as assistant lighthouse keeper from 1918 to 1926.

In the 1920s, he earned seven cents per crate packing tomatoes and peppers for farmers. In 1928, he moved to the house with his wife, Ruth, who died in 1958, and resided there until shortly before his death in 1982.

Ken Cox's mother, Carol, remembers visiting Uncle Clarence's house as a child with her mother. She slept on a mattress in the hall by the front door to take advantage of any cool air. Cox's most vivid memory of Uncle Clarence was in the late 1970s after the bridge was built. A group of people sat on his front porch arguing the pros and cons of the bridge. Rutland, angry about the onslaught of tourists, suggested that "the bridge should be blown up."

THE BURNAP COTTAGE

This fishing cottage was built in 1898 on Tarpon Bay on land homesteaded by Sam Woodring. In 1902, a retired Toledo businessman, Hiram Burnap, purchased a cottage from the Woodrings to use as a fishing retreat during the winter months. Burnap died in 1910, and the cottage was sold twice before James and Nellie Brewster bought it in 1933 and expanded the bungalow with a two-story addition of four rooms.

The Brewsters occasionally rented out the cottage before selling it in 1967. The new owners, wanting to build a larger home on the waterfront property, donated the cottage to the city for use as part of the historical village. Volunteers, known as hammerheads, removed the second-floor addition, restoring it to its original fishing cottage look.

Local legend tells of an itinerant preacher who held services in the Burnap Cottage. This might have been George Gatewood, whose wife ran a small store at Reed's Landing, less than a mile from Woodring Point. Some docents at the village think that Nellie Brewster's spirit still inhabits the house. The neighbors reported that a light went on in the empty cottage the night Mrs. Brewster died.

MISS CHARLOTTA'S TEAROOM

The tearoom was constructed in 1926 by Frank and Ernest Bailey. Sitting at the foot of Bailey Road, it was to have been a gas station servicing traffic that came to the Matthews Wharf where the Bailey's Store was located. This intended use is shown by the wide front overhang, which would have protected a pair of gas pumps.

The hurricane of 1926 changed that idea. The wharf and all the buildings were destroyed, but this structure, set back on the shore, survived. It became a temporary store for the Baileys until a new structure was built on land. Once that store was completed, the building was turned over to Charlotta Matthews, who converted it into a tearoom.

Charlotta, single and well into her thirties in 1928, had just returned to the island to help her mother run the family's hotel, the Matthews. The kitchen of this hotel served as the base for most of the cooking done for the tearoom. Open only during tourist season, Charlotta, nicknamed Scooter, served tea, pastries, soup, sandwiches and lots of gossip during the hours the ferry operated.

Miss Charlotta's Tearoom became a popular spot for meeting friends, waiting for groceries from Bailey's Store or queuing up to play a game of miniature golf. It closed in the spring of 1935 and never reopened after

the Kinzie brothers moved their ferry service closer to the lighthouse. Soon afterward, the tearoom was converted to a house for a schoolteacher and, still later, a residence for Bailey employees or family members.

When the buzz of the bulldozers threatened the cottage in 1992, the structure was moved to the historical village and restored to its 1928 look. It has now entered a new life as a museum.

THE SANIBEL SCHOOL FOR WHITE CHILDREN

In 1903, the school was transported from the corner of Bailey Road and Periwinkle to land donated by the Riddle family. Rollers and a winch brought it to its new site.

Named the East End School for White Children, it was representative of its day. The teacher's desk was on a raised platform, where classes of sometimes no more than three students recited their lessons. A wood stove stood on one side of the room, and the student sitting closest had the task of stoking it. At the back of the room, pupils hung their coats that often smelled like fertilizer from a sack kept nearby for the school garden.

Sometime before 1930, the bell disappeared, but it was found in the brush on the property next to the school when the structure was moved for the last time. It still retains the original windows and much of the tongue-in-groove bead board commonly used on interior walls and porch ceilings at this time. A chimney was added between 1915 and 1926. The upright piano turned the little building into a perfect setting for community activities until the Sanibel Community Center.

The old schoolhouse was moved and restored to its original condition by the village volunteers, called "the hammerheads." *Photo by Manfred Strobel.*

In 1932, a second room was constructed, allowing the structure to house grades one through eight. To brighten the rooms, more windows were added, along with indoor plumbing. Closed in 1963, it was used until 2003 as a theater, after which it closed permanently. Sam Bailey talked fondly of his days at school: "My favorite part was recess. When I went to school there were two rooms (first through third grade and fourth through eighth grade). I put a dead snake in the teacher's desk and got into big trouble…we used to play baseball using a coconut."

Island resident and local photographer Jim Pickens was fifteen years old when his family moved to Sanibel in 1952. At first he attended the two-room school and then high school in Fort Myers. Pickens remembers getting up at 5:30 a.m. to catch the school boat from Bailey's dock to Punta Rassa, where they met the school bus at 7:00 a.m. The bus then picked up kids along McGregor before heading downtown to Fort Myers High. The students didn't return home until 5:30 p.m. He sums up the experience: "That was an eleven-hour day, and I wouldn't trade it for anything!"

In 2004, the building was moved to the historical village and restored. Some of the original desks and books have been added to the displays. Visiting children still enjoy seeing this old school and ringing its bell.

THE OLD POST OFFICE

This little building stands as a reminder of some of the hardships islanders endured while receiving and sending mail. The history of postal service on the island is a clear snapshot into its past. William Sumner Reed became the island's second postmaster in December 1894 and held the title for forty-four years. His post office was in his father's house next to the Reed dock on San Carlos Bay. Rural free delivery began on the island in 1900 and was one of the nation's earliest routes. The little post office remained abandoned until the Bailey brothers moved it to the Sanibel Historical Museum and Village in the late 1990s.

THE OLD BAILEY'S STORE— THE SANIBEL PACKING COMPANY

Hurricanes have a history of changing the island. This structure, located on San Carlos Bay, was the Bailey brothers' second store after the 1926 hurricane destroyed the first.

In 1896, Frank and Ernest Bailey purchased Geraty's plantation store and called their business the Sanibel Packing Company. It thrived in that location, acting as store, warehouse, packing center and distribution point for steamer runs between Fort Myers and the islands.

At the Western Union office, which was located in a corner of this first store, word first reached the United States that the warship USS *Maine* had suddenly exploded and sunk in Havana, Cuba, in 1898, leading to the start of the Spanish-American War.

After the storm, the Baileys built a new store on a substantial beach ridge about one hundred yards west of the lost Matthews Wharf. Gas pumps gleamed under the portico, and the little building that was to have been a gas station was moved and converted into a tearoom. This new store was constructed to prevent hurricane damage. The gabled ends were tied down with braces, and between the inside and outside siding, diagonal tongue and groove boards strengthened the walls. The backroom shed extension was built as part of the store, but in 1952, another rear extension was added, the gas station portico was converted into a room and the entrance was shifted to the south wall.

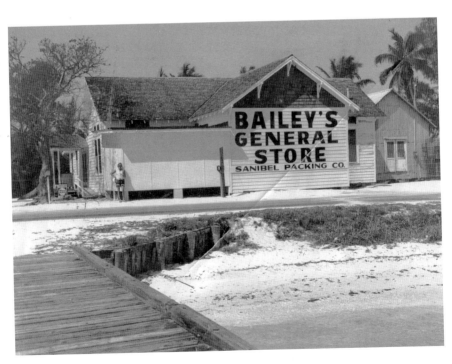

The second Bailey's Store and wharf, circa 1950. *Courtesy Sanibel Public Library.*

With telephone and telegraph links, it became the communication center for the islands. Residents voted there and caught up on the latest news from the island and "overseas" (the mainland). According to Sam Bailey, "It wasn't before the mid-fifties that one hundred voters lived on the island."

Francis Bailey has fond memories of the store's early years: "My father always used a quill pen in those days. But our cat kept knocking over the inkwell. We used to have snowball fights. We'd throw a block of ice on the dock and the kids would grab the sides, make snowballs and have a fight."

Sam also relates an interesting story about his uncle. Ernest was a favorite with the ladies from the North, who always liked to flirt with him. He was considered one of the original hippies, wearing shoes without socks. In an interview for an island paper, Sam reminisces about his childhood on the island: "We were three brothers, and we had a big yard and the beach. There were no fancy ball fields, but we played ball and made up our own games. The mosquitoes were terrible in the summer, but we knew it was a reality, so we'd go to the beach, where it wasn't so bad if there was a breeze."

In the early days, store patrons gave their order to the clerk, waited at the nearby tearoom and knew that the Bailey slogan held true: "If we don't have it, you don't need it." Frank Bailey was the resident's storekeeper, banker, justice of the peace and friend.

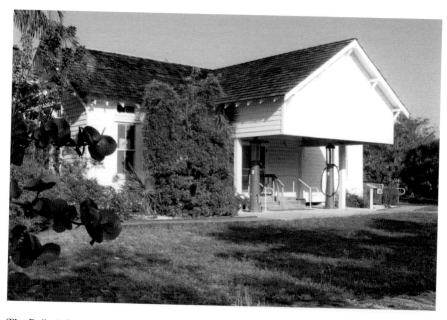

The Bailey's Store restored today at the historical village. *Photo by Manfred Strobel.*

Morning Glories

This charming cottage was ordered from a 1922 Sears and Roebuck catalogue. It was the Springwood model and arrived in thirty thousand pieces by rail and barge to a street on the island wide enough to accommodate the flatbed truck that carried the house to its location on San Carlos Bay. The owner, Martin Mayer, named it Morning Glories after it was completed in 1926 at a cost of $2,211.

The building, donated to the historical village in 2001, was unusual for the island. It had two bedrooms, a bathroom, built-in bookshelves, kitchen cabinets, a hidden ironing board and large closets. A generous porch that took advantage of the bay view was built across the back of the house in 1924. The side porch was enclosed in the 1950s to make a small sunroom. Sanibel legend tells a story about the Mayer children. With only one bathroom, one of them would lock the door from the inside and climb out the window while the other waited impatiently outside the door.

While assembling the cottage, workers made a couple of errors, which remain today. Look for the wall lights next to the fireplace.

The Packinghouse

This replica is characteristic of the structures used by the Baileys and other farmers to house their produce. Residents carted their goods to Bailey's dock and stored the produce until the steamers or ferries arrived. Today, it houses the historical books, records, furniture and clothes that are displayed throughout the village.

A SCHOOL FOR BLACK CHILDREN, A MARINA AND A HOME FOR A CAPTAIN

Tarpon Bay Road

Intertwined with the white settlers was a group of blacks, many of whom fled poverty to eke out a living. In 1867, Nelson Tillis, a black American, settled one hundred acres on the north side of the Caloosahatchee River opposite Fort Myers. Over time, many other black Americans came to join him and farm the area now known as Dunbar.

In 1913, the Williams Academy for Black American Children was built in Lee County.

There was a labor shortage on the island during World War I, and along with the devastation brought on by the 1921 hurricane, the island population diminished. Black families were encouraged to come to the island and fill in the void. Isaiah Gavin, who established the first black family on Sanibel, worked for one dollar a day and was glad to get any job.

Blacks began farming in 1917 and found success growing tomatoes, limes, eggplants and bananas. The island had a nine-month growing season, from October until June. Oscar Gavin, Isaiah's descendant, started a successful rubbish removal business in the early 1950s, using his truck for hauling garbage to the mainland.

Another of Isaiah's sons, Edmond, a gardener and sharecropper, devised a method to deal with the swarms of mosquitoes. He designed the first automatic controlled defogger. These pests often covered windows and screens, making day appear as night.

Profitable farming ended in the late 1920s, so owners of farm buildings turned them into guesthouses or hotels. Black families turned to other trades and became cooks, plumbers or worked at hotels.

A School for Black Children (#24)

In 1909, while Sanibel was experiencing some growth, the Baptist Convention decided to build a church but abandoned it for lack of funds and parishioners. As a result of segregation in the South, black children were forced to leave the island and attend school in Dunbar. Isaac Johnson gained permission to use this empty church as a school for blacks in 1924.

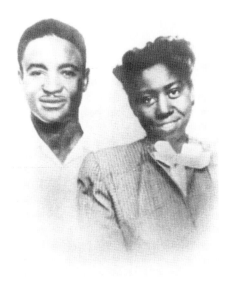

The wedding photo of Eleanor and Edmund Gavin in 1933. *Courtesy Sanibel Public Library.*

Edmund Gavin approached the Lee County Board of Public Instruction with a request for classroom materials and a teacher. Told that a school must have an enrollment of at least seven children, Gavin replied that his family had twenty.

Lily and Company jewelry store, once the Sanibel School for Black Children. *Photo by the author.*

73

In 1929, the Baptist Church sold the building to the school board for $1,500. A small addition became the modest quarters of Hazel Hammond, who taught there until 1933. With the onset of World War II, Sanibel's population dwindled to ninety, so the school closed in 1940, after which the children were bused to Fort Myers.

It was a long day for these island children who attended school in town. Some of the kindergarteners were finished at noon and had to sit on the floor of the hall until 3:00 p.m., when the bus came to return them to the ferry. Because of this hardship, in 1964, parents convinced the school board to integrate, and Sanibel became the first to do so in Lee County.

Through the years this church/school has functioned as a home, art gallery and store.

THE COOPER HOMESTEAD— THE OLD HOUSE SHOPPES (#25)

Subsequent to running a sawmill in North Fort Myers, Captain George Madison Cooper built this house in 1891 on 160 acres. He added three tenant houses and a packinghouse, which served as a polling place for islanders until

The Old House Shoppes and the Over-Easy Café were originally part of the George Cooper Plantation. *Photo by Manfred Strobel.*

1910. Cooper traded exotic woods like mahogany to Honduras and fruits and vegetables to Alabama. The *Fort Myers Press* reported that he shipped one-third of the one thousand crates of tomatoes leaving Sanibel during one week in 1894. An article appearing in the paper in 1895 tells the story: "Mr. G.M. Cooper of Sanibel will begin shipping tomatoes this week. The deer have been eating up a large quantity of tomatoes…and islanders have only succeeded in killing one of the 'varmints' so far, though they have used every endeavor."

He and his second wife raised six children, four of them from his previous marriage. The last two, Genevieve and George, were born on Sanibel. Their home, by early Sanibel standards, was large and comfortable with an unusual feature. The well or water source was inside and therefore very convenient. The farm was sold in 1913, and the family moved to Fort Myers, where Cooper died in 1916.

Known as the Olde House Shoppes today, the second story was reached from an outside staircase, hidden in the back. Employees tell tales of a ghost rearranging clothes displayed around the store.

THE OLD POST OFFICE— THE OVER-EASY CAFÉ (#25)

In 1943, a new location for the post office was selected. Some islanders wanted it in Bailey's Store at the mail boat landing, others at the ferry landing. Captain Kinzie solved the problem when he erected a small building as a post office on his property at the lighthouse end and leased it to the government. Scotia Bryant continued to sort the mail after it had been dropped off at the Bailey's dock and driven to the ferry dock.

When Scotia retired, the post office returned to Tarpon Bay Road and the Old Cooper homestead. Now the little post office is known as the Over-Easy Café. Seventy-six years later, it's gone full circle. The new, larger office was built farther down Tarpon Road in the early 1980s.

TARPON BAY MARINA (#26)

When George Madison Cooper moved his family to Sanibel in 1890, he built Tarpon Bay Road across his property. He needed to transport his produce to the long dock for shipment to markets up north. The Cooper family sold the farm in 1916 to a Pennsylvania man who built a packinghouse at the end of

The Tarpon Bay Marina looking out into the bay. *Photo by Manfred Strobel.*

the pier at Tarpon Bay. Produce was shipped from there until the building became a store in 1921.

At the end of World War II, Clarence Rutland bought fifty-five acres on Tarpon Bay for about $1,800. He then sold some of the land in the 1950s to Dewey Miller, who built a little shop and fish market where he rented boats and sold tackle.

Fishing guides Bob Sabatino and Esperanza Woodring, along with local resident Mark McQuade, used this marina as a focal point for business and pleasure. "People would come to the islands and they'd want someone to run the boat and point out places to fish," Sabatino recalls. The boats the marina rented were fourteen-foot wooden skiffs with ten-horsepower motors.

Dewey had a number of fish tanks at the marina with hermit crabs and other local specimens, and children flocked there to see his collection. An ardent sheller, Dewey displayed his fish tanks and other marine specimens at the island's yearly shell fairs. Tarpon Bay Marina is still known for its gift shop, boat rentals and fishing charters.

A Private School, an Inn and a Cemetery

West Gulf Drive

After listening to the romantic tales of Reverend George Barnes, Kentuckians Will and Hallie Matthews traveled to Sanibel. Hallie, who arrived with her four children, all babies, and a dying father-in-law, talks about her family's trek to their new home in 1895: "It was the year of the cotton expositions in Atlanta…and the railroads were crowded and gave terrible service. Our train had nine sleepers and the Pullman we were in had only a few glasses of drinking water." She describes a beautiful trip through the waters of Charlotte Harbor to Sanibel, where they landed about two o'clock in the afternoon. Her husband, Will, met them but had a hard time getting them off the dock because of all the fiddler crabs. "I thought they were spiders and I refused to get off the pier to the amusement of all on the beach…It was indeed a fairyland with the yellow luscious citrus fruit on all sides and the graceful palm trees."

THE ISLAND INN (#27)

Will returned to Louisville because of his job, but Hallie and the children never went back. They rented a cottage from Jane Matthews (no relation). Jane became a frequent visitor and suggested she pay for her meals. Other renters, who enjoyed Hallie's cooking, did the same, and by the end of the season, a home restaurant was born—the Matthews. This enterprise was so successful that after Will returned from Louisville, he and Hallie bought property on the beach, built a home and started providing rooms and dining facilities for winter residents.

Hallie Matthews beside a station wagon from the Island Inn. *Courtesy Sanibel Public Library.*

In 1937, the name was changed to the Island Inn. Both Will and Hallie were well suited as innkeepers. While Will, tall and easygoing, viewed life and his fellow man with tolerance and good humor, Hallie, bustling and efficient, was everybody's friend. The hotel did so well that by 1917, a larger building, known as the Barracks, was added to the resort. It was by far the most impressive building on the island, with three stories, four porches and thirty-one rooms. A dock into the Gulf washed away twice, and the Barracks was remodeled and remained in use until 1970, when it was torn down for new construction.

Will Matthews died in 1927 and was buried in Louisville. With the help of her daughter Charlotta, Hallie continued to run the hotel. She died on Sanibel in 1950, but the hotel remained in the family until it was sold in 1957 to a group of longtime guests who had formed the Island Inn Corporation.

Stories abound concerning happenings at the hotel. Prohibition posed no major problem to the island. In the 1940s, the manager of the hotel asked Frank Bailey, then justice of the peace, to investigate strange noises on the hotel grounds. Bailey smelled fermenting mash and followed his

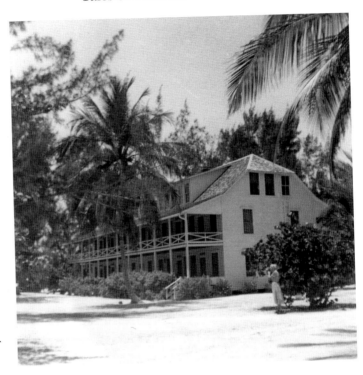

The Barracks
at the Island
Inn, circa 1940.
*Courtesy Sanibel
Public Library.*

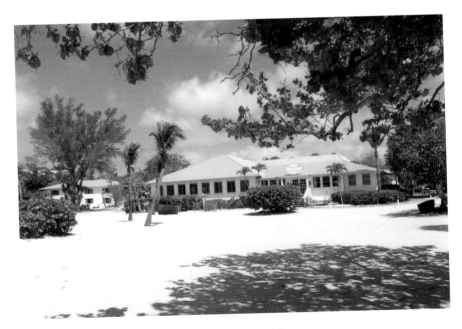

Buildings at the Island Inn today. *Photo by Manfred Strobel.*

nose to the source of the trouble: an islander operating his still behind the servants' quarters.

During the 1960s, Jack and Milbrey Rushworth ran the inn. They established the tradition of Thursday afternoon buffets, where food was served on long tables under sea grapes overlooking the Gulf. Local health department regulations mandated that the uncovered beach buffets be terminated, and the midday meal was box lunches provided on request.

The Island Inn still remains a destination for old and new visitors.

GRAY GABLES (#28)

Although most of the early pioneers lived at the east end, some fearless folks ventured farther down the island. Laetitia Nutt and her daughters were one of the first families to establish a homestead along the Gulf. Originally from Shreveport, Louisiana, they brought everything needed for farming, including oxen and a cart. The Civil War widow had heard about Sanibel from her friend Jane Matthews, who had built a wharf on San Carlos Bay.

Gray Gables, constructed in 1889, served as a boardinghouse and school. The original house, made of board and batten siding, has a primitive pattern of gables and a shed metal roof, along with a series of large screen porches in the rear, side and front.

Laetitia Ashmore had married Leroy Nutt prior to the Civil War. In 1862, he was asked by the governor of Louisiana to raise a company of Partisan Rangers. Leroy hesitated, not wanting to be separated from his wife and daughters. Laetitia told her husband that he could go fight if she could follow everywhere in a covered wagon. In order to keep her bargain, she and her three daughters drove two mule team wagons through deadly battlegrounds, thick forests and raging rivers to follow the Rangers.

In *Courageous Journey*, Laetitia's journal account of her almost two-year trek, she offers personal insights into the war and the conditions of the countryside. She notes her frustration with the mules: "After we crossed the first deep bayou they [the mules] jumped up the bank in such haste they broke both singletrees and left us backing into the water."

She and her daughters found rooms in proximity to the Confederate camps. Neither her children's illnesses nor dangerous cannon fire could deter her from meeting her "darling" husband. Even in time of war, southern hospitality must not be forgotten.

When the size of her boarding rooms permitted, she entertained many callers. Robert E. Lee and Jefferson Davis were part of her soirees. Captain

Laetitia Ashmore Nutt was the first postmistress and schoolteacher on the island. *Courtesy Sanibel Public Library.*

Gray Gables is the oldest building on Sanibel still being used as a residence. *Photo by Manfred Strobel.*

Nutt was captured in 1863 and held until he was exchanged for a Yankee. Until his release, Laetitia stayed by his side to nurse and care for him, leaving occasionally to see her daughters, who were being cared for by a family friend. After the war, the family was reunited. When Captain Nutt died, Laetitia and her daughters established a homestead on Sanibel. She knew that ten acres was all a person could realistically tend, so she sold off a portion of the land for ten to twenty-five dollars an acre. Before long, she and her daughters were again comfortably well off.

She was the island's first postmaster and taught school in her home, receiving three dollars per month per student from the county school board. Laetitia died in 1914 and was buried in a cemetery adjacent to Gray Gables.

Gray Gables, a historic landmark, is still owned by a cousin of Laetitia's.

GRAY GABLES CEMETERY (#28)

The small family cemetery harkens back to the old southern plantation where members of a family were buried on their own property. Since Laetitia Nutt came from the old South, this family plot was very appropriate. Under the

The Gray Gables Cemetery today. Members of the family are buried next to their home in an old southern tradition. *Photo by Manfred Strobel.*

shade of low sea grapes, buttonwoods and flowering bushes, Laetitia Nutt, her brother James Ashmore, her three daughters and Nannie's husband, Nelz Holt, are interred.

Daughter Cordelia is remembered by some islanders as the "brightest of them all." She was a Bible scholar and established the United Daughters of the Confederacy, naming the organization after her mother. She also helped found the first Lee Memorial Hospital and the Jones-Walker Hospital for Negroes in Fort Myers. Nannie married Nelz Holt late in life. He had loved her for years but was afraid to speak while her mother was alive. Lettie was the last of the family to die. She is remembered as the "strict schoolteacher."

J.N. "Ding" Darling Wildlife Refuge (#29)

An affable and talented man, Jay Norwood Darling began his cartooning career in 1900 with the *Sioux City Journal* and retired fifty years later. After joining the *Des Moines Register* as a cartoonist in 1906, he began signing his cartoons with the nickname "Ding," derived by combining the first initial of his last name with the last three letters. Syndicated in 130 daily newspapers, Darling reached an audience of millions with cartoons noted for their wit and political satire. He was awarded Pulitzer Prizes in 1923 and 1942.

For many years, Darling had a winter home on Captiva Island. Through the efforts of his island neighbors and the J.N. "Ding" Darling Foundation, a refuge was created on Sanibel with land donated by concerned citizens or acquired by the federal government. This 6,300-acre refuge is administered by the U.S. Fish and Wildlife Service, which has protected habitat for wildlife since 1945. It was renamed in Jay Darling's honor and officially dedicated to him in 1978.

PIONEERS FISH, PLAY AND ARE LAID TO REST

Sanibel-Captiva Road

G eology played an important part in the formation of the island. The constant action by the surf tended to build up and tear down the seaward side of Sanibel, shaping contours and throwing up long ridges of sand and shell. Eventually, seven to twelve sets of ridges were formed parallel to the Gulf beach. The highest one—ten feet—occurred at Wulfert Point.

The Calusa Indian traders came first, followed by the pioneer farmers. After the hurricanes deluged the area with salt water in 1921, farming ended. Within a short time, wildlife, such as eagles and gopher tortoises, reestablished communities.

WULFERT POINT (#30)

Just like Tarpon Bay and the Lighthouse Reservation, the lack of good roads also isolated Wulfert, making the area residents dependent on water for transportation and communication. A dock was quickly built by landowners to enable boats from the mainland to bring people and essential goods.

In 1897, a post office was established, and Jennie Doane, the first postmistress, decided to name it after herself. Mason Dwight objected vehemently. His family was the first to arrive in the area, so it was renamed Dwight Settlement. When the postal inspector learned that the name was still in dispute, he declared the post office be called Wulfert, after no one in particular. And so the name remains today.

The dock at Wulfert Point in the early 1900s. *Courtesy Sanibel Public Library.*

In the 1890s, Dwight placed an ad in a Texas newspaper for a partner to help him clear his land and plant an orange grove. A man named Holloway traveled from Toronto, Canada, and ended up running the store on the dock.

Mississippi River boat pilot Oliver Bowen, his wife, Mary Dos Santos, and their children arrived in 1887. Traveling from Port of Spain, Trinidad, in the family's sailing vessel, they loaded the boat not only with household effects but also with lumber, slate shingles and nails to build a house and barn. Oliver also brought agave plants, which still thrive there. He had hoped the sap might prove to be a substitute for rubber. The project failed, and Mary would later say that the only time Oliver ever made any money was when he killed a rattlesnake and sold the hide.

Mary ran the farm, growing vegetables for northern markets.

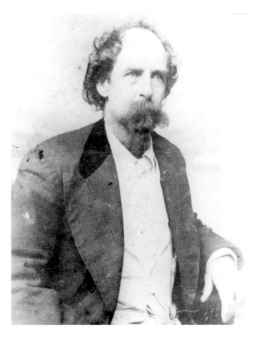

Oliver Bowen, one of the first settlers at Wulfert. *Courtesy Sanibel Public Library.*

Not interested in farming, Bowen often delivered produce and eggs to the San Carlos Bay Hotel on Pine Island. Sometimes, he sailed down the river to Fort Myers and visited Thomas Edison. The two would discuss Bowen's experiment, for Edison, too, sought a rubber substitute.

But Oliver's health was failing, and he spent more time in his hammock slung between two trees next to his well. When he died in 1894, Mary completed her homestead requirements and, with her son Albert, returned to Trinidad. She died in Los Angeles in 1922.

THE FAMILIES OF WULFERT

In 1897, the Doanes arrived on Sanibel, where they raised chickens and tended a garden. Their neighbors believed that they had come to Wulfert to establish a spiritualist colony. Though the colony never came to fruition, the Doanes continued to hold séances where tables moved and ghostly voices spoke. According to an interview with Pearl Stokes, whose grandparents were Amanta and Clementine Gibson, Doane either bought property or rented from Dwight/Halloway.

In 1902, there were ten families living in the area. David Sumner taught nineteen students in the home of S.L. Roberson. That same year, a schoolhouse was built south of the landing near today's intersection of Wulfert Drive and Wulfert Road. It was well attended until it combined with the Captiva School in 1917.

Josiah Dinkins filed his claim in 1898 and lived in Wulfert for twenty-eight years. He was a steamboat engineer and married a woman who was a fat lady in a circus. Dinkins owned acres of citrus fruit and grew vegetables that he shipped to Fort Myers via the Kinzie ferries. W.L Hunter also homesteaded the area and married Linnie Gibson. Their daughter Pearl was born on the island in 1909.

Pearl Stokes also talked about the burial of Oliver Bowen:

> *Bowen was old then and just sat by his well. His second wife, Mary, a "Trinidad woman," did all the work. After he died, his wife said he requested to be buried in his well. Years later, his two sons by his first wife came back and asked my uncle Arthur to show them his burial site. When Arthur went back the next day, the site was opened and the body was removed. The two Bowen men and their boat were gone. Both men claimed to be very wealthy and living in California. Years later, they returned and brought the Gibson family a bushel of fruit—small compensation for what they did.*

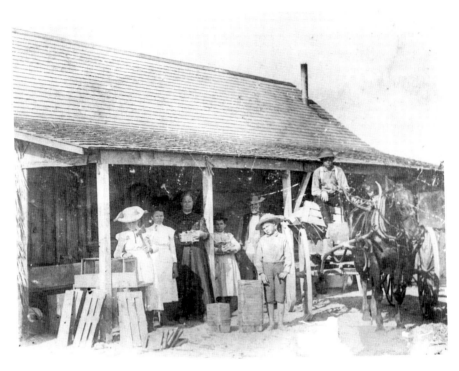

A photo of the Gibson family, who homesteaded Wulfert Point in the early 1900s. *Courtesy Sanibel Public Library.*

Pearl went on to describe Captain Dinkins as a very small man. His mail-order wife was over three hundred pounds, but they were very much in love. After she died and the 1926 hurricane salted all the farmland, Dinkins sold his property to Clarence Chadwick—except for the acre used for the Wulfert Cemetery. He didn't realize that Chadwick would be so mean as to not give public access to the cemetery. But Chadwick refused, and the cemetery became wild and unattended.

The shallows kept steamers from docking at Wulfert, and all freight, mail and passengers arrived and departed by way of the bulkheads (building on pilings placed offshore in deeper water) constructed about a mile and a half off the shore. In 1914, the Lee County commission appropriated money in order to dredge a channel five or six feet deep at low tide, which provided access to Wulfert for steamer service, thus eliminating the time-consuming transfers of mail, cargo, passengers and produce at the bulkheads.

During the 1920s, a resident known as "Old Man Kessen," a supposed gator hunter, farmed on an Indian mound near Wulfert. While planting his vegetables, he discovered an array of bones and ancient artifacts (or

so he claimed). Not wanting to miss an opportunity, he opened a museum displaying the curios he had collected.

Due to the Depression, the number of farmers fighting in World War II and the poor weather, Wulfert turned into a ghost town and never recovered. Recently with the popularity of the J.N. Ding Darling Wildlife Preserve and the Sanctuary housing development, Wulfert has returned to a viable community. However, many descendants of the original families yearn for the past.

MURDER IN WULFERT

When Rudolph and Agnes Jenny came to Wulfert in 1890, they were looking for a quiet existence where they could raise their children. These migrants from Kentucky arrived on Sanibel with their nine children. In the late 1930s, Edwin Jenny, a descendant, married a divorcée, Bessie Santini. This marriage would bring tragedy and infamy to the family. A month after the marriage, Bessie's ex-husband, Victor Santini, killed Edwin. Supposedly, Victor was distraught. Was it an accident, self-defense or murder? There are no records showing that Victor went to trial. He resumed his life in Marathon, Florida.

WULFERT CEMETERY (#31)

The only dedicated cemetery on Sanibel, it consists of about one acre off old Wulfert Road on land homestead by Josiah Dinkins. When his wife died, he erected a monument in her memory, although she and he were buried in Fort Myers.

The first burial was in 1904, when Stephen Decatur Hall died. He was pioneer Arthur Gibson's grandfather. Other graves are those of Callie Carroway, who died along with her baby in 1901; her father-in-law, Mr. Carroway Sr.; Willie Brady, who died in 1906; Mr. Dewey, a farmhand; Mason D. Dwight and Mrs. Dwight; and John Henderson and Mrs. Henderson, who died after 1959. That same year or earlier, a county commissioner came to Wulfert to inspect this burial site, but recent efforts to locate this cemetery were unsuccessful.

THE WHITE HERON HOUSE (#32)

A two-story farmhouse that peeks between the straggly pines on San-Cap Road stands as a reminder of the pigheadedness of a couple of the island's early pioneers. Lime plantation owner Thomas Holloway built the house on the water at Wulfert Point in 1905. Holloway and his partner, Josiah Dinkins, were convinced that this area was ideal for farming, and locals quickly leased parcels. These farms were so successful that the products were shipped to the mainland.

Farming ended after the hurricane of 1926, when the tenants fled to Fort Myers and Punta Gorda. Holloway and Dinkins were forced to sell their acreage at a loss. Because of the economic opportunities at the time, John Oster, inventor of the Oster blender, and Clarence Chadwick, inventor of the protective paper used for bank checks, were acquiring property on Sanibel and Captiva. These fierce competitors jumped at the chance to buy this farmland. Oster purchased the farmhouse and the strip of land across the tip of Wulfert peninsula, while Chadwick bought the adjoining acreage.

An argument began after Oster announced he was moving the house to a piece of property he owned on Clam Bayou but needed to cross a dirt road that bordered Chadwick's land. Chadwick, claiming it was his private

The White Heron House on San-Cap Road. *Photo by Manfred Strobel.*

property, refused to let Oster use the road. Chadwick suggested moving the house by water and offered to rent Oster, for an exorbitant fee, one of his barges moored at the tip of Captiva. Oster, enraged by this blatant ploy for money, searched for his own alternative. After scouring public records, he obtained a legal opinion that the road was public property. Oster sent the affidavit to Chadwick, who tore it to smithereens. The feud between these two wealthy men proceeded at full throttle. Islanders considered the battle great fun and started to take sides. Most were against Chadwick on account of his haughty and abusive manner.

The day of confrontation arrived when Oster paid workers to lift the house and load it onto a flatbed truck. Taking the wheel of the tractor towing the truck, Oster maneuvered the house slowly down the disputed road. Not wanting to miss out on the fun, islanders took positions on both sides of the road, expecting the inevitable conflict. They didn't have long to wait.

Chadwick showed up in a chauffeured limousine and ordered the young driver to block the road. Oster continued to move his tractor toward the limo. Chadwick rolled down his window and started cursing and shouting at Oster, who returned the epithets, all the while threatening to call the law. Oster refused to stop. Chadwick demanded his driver stand firm. However, at the last minute, the chauffeur panicked and drove off the road into a tomato field, leaving Chadwick eating Oster's dust. The locals applauded. Oster successfully moved his house to its present location along San-Cap Road on Clam Bayou and named it the White Heron House after surrounding it with a cluster of small cottages—like a mother hen with her chicks.

During the 1950s and 1960s, the house was the main building of the White Heron Resort on Clam Bayou. It fell into disrepair before being purchased by a grandson of Wild Bill Hickok, who began the restoration. The next three owners continued the renovation, adding a wing and a beautiful pool. The White Heron House is listed on the city's Historic Register, but who knows what would have happened if John Oster hadn't won this game of chicken with Clarence Chadwick?

INTO THE WILDERNESS

The Isles of Captiva and Buck Key

Historians surmise that the first human inhabitants of Captiva were Indians, probably ancestors of the Calusa. In 1927–28, archaeologists unearthed bones on what is today South Seas Plantation and found two sets of burials. Those on top were piles of broken bones, probably moved from somewhere else. Below this strata were older skeletons lying in the prone position, with limbs bent. Water had hardened them, and it was necessary to detach them with a hammer and chisel. More than seventy skulls were removed, some believed to be more than one thousand years old.

Some scholars suppose the name Captiva springs from old Spanish maps calling the pass between Captiva and Cayo Costa *Boca de el Cautivo*. A more romantic story concerns Juan Ortiz, a young male captive of the local Indians. During the 1500s, he sailed to Florida as part of an expedition looking for adventurer Panfilo de Navarez and his men, who had disappeared. In the spring of 1528, Navarez sailed to Florida to grab some of the great wealth reportedly held by the Indians. A massive storm drove his ships into the San Carlos Bay area. Navarez and his men set out to explore the interior of the island, leaving the captains of his ships instructions to return to Spain if he didn't reappear in a few months. Unable to find the explorer after nearly a year, the ships returned to Cuba.

Navarez's wife, refusing to accept her husband's death, equipped a fleet at her own expense to scour all the inlets and waterways of the west coast from the Florida Keys northward. Arriving at Captiva Pass, an area where Navarez and his men were last seen, the captain ordered the vessel to turn into the mouth of the inlet. Through his spyglass, he saw a group of Indians

CAPTIVA ISLAND

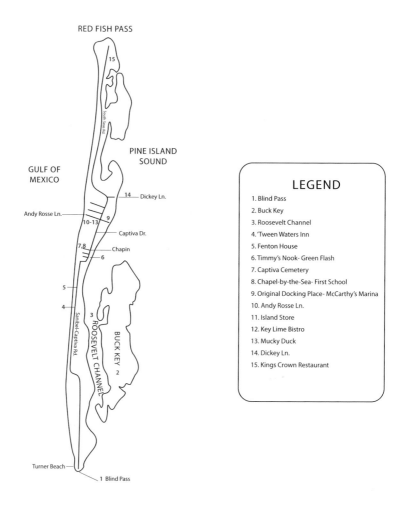

A map of Captiva historical sites. *By Julie Scofield.*

waving and pointing to a paper stuck into the slotted end of a stick thrust into the sand. Could this be a message from the missing explorer?

Warily, the Spaniards dropped anchor and sent Juan Ortiz and another sailor to retrieve the paper. They were right to be cautious. The Indians swooped down on the men, killing the sailor and taking Ortiz captive. Afraid that his ship would be attacked by more Indians, the captain smartly ordered the anchor hoisted, and the small vessel fled into the open Gulf. Released a few years later, Ortiz returned to Spain to weave many a yarn about his captivity.

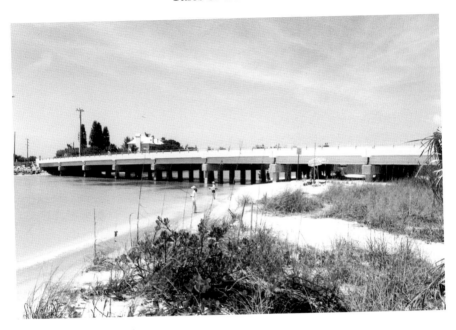

Blind Pass Bridge today. *Photo by Manfred Strobel.*

William Binder first visited Captiva by accident as a young boy. Born in Austria, he was en route to New Orleans on a German freighter when it wrecked off Boca Grande. Unable to swim, he clung to some floating wood and was eventually carried by the currents to Captiva's shores. Binder remained there for some weeks, living off wild fruit and seafood. He built a small boat and was able to paddle to Pine Island, where locals helped him return home. In 1888, now thirty-eight years old, he returned to homestead the central part of the island. His home was a crude palmetto-thatched hut with a dirt floor. He stayed alone there for ten years and supported himself in his declining years by selling off his property. He died in 1933 and is buried in the Captiva Cemetery.

Hurricanes have affected Captiva, especially the one in 1921 that destroyed part of the island, splitting the land in half at Red Fish Pass, the northern point of South Seas Plantation. The one in 1926 sealed its fate, and today beach renourishment is needed every five or six years to keep the Gulf from decimating what's left of the land.

BLIND PASS BRIDGE (#1)

In 1911, Lee County ran a ferry to Captiva. Operated by local farmer John Boring, passengers and freight were disembarked at bulkheads. But as the island grew, wealthy residents wanted to use their cars on the island. A decade later, channels were dredged through the pass, and by 1918, Boring's ferry was replaced by the first bridge.

County commissioner Dr. Turner ordered J.P. Loftin to construct a wooden bridge that was eleven feet wide and eight feet above high water. However, it was too narrow for two cars to pass, so the rule was that the first vehicle on the bridge had the right of way and the second had to back off. Often there would be heated arguments about that situation. According to island resident James Loomis, the bridge was dangerous: "I can still see the big fat-headed nails that were sticking up, probably a sixteenth of an inch or more, and I often marveled about driving across that bridge, not understanding why every single tire wouldn't be blown out before you got to the other side."

The early road beyond the bridge—when surveyed by Turner—extended along the Gulf beyond Redfish Pass to Upper Captiva and Captiva Pass. Both sides of the road were planted with Australian pines. On the left side going north was a special six-foot-wide strip for walking.

Clarence Rutland, who owned a Model T Ford, offered taxi service. Drummers (salesmen) from Knight and Wall or Snow & Bryant in Tampa would arrive on the steamer at Sanibel to sell goods to scattered islanders.

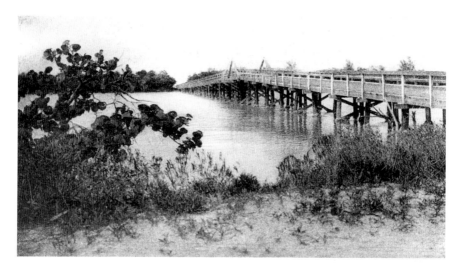

A 1927 postcard of the Blind Pass Wooden Bridge. *Courtesy Sanibel Public Library.*

Rutland would meet them at the landing and taxi them on a jolting ride over Sanibel, stop along the way at each island residence, take them over the bridge and drive along the shore of Captiva at a cost of twenty-five dollars for the round trip.

Thomas Edison and Jay Darling seemed to enjoy rumbling over this wooden structure with a hump in the middle on their way to fishing vacations on Captiva. The seclusion attracted more famous people. Anne and Charles Lindbergh visited the island and rented a home from Herman Dickey, their privacy guarded by the islanders. This wooden bridge was replaced by a two-lane concrete bridge in 1954.

Buck Key (#2)

Two hundred yards off Captiva's southeastern shore is Buck Key, named for the large deer that roamed there. It was little more than a mile long and perhaps less than half a mile across, yet ridged with Indian mounds, it supported the homesteads of three families and a bachelor uncle.

Herbert Brainerd and his wife, Hattie, arrived with their two children and, during their five years on the island, buried four babies. They grew

Typical island birds and wildlife. *Photo Manfred Strobel.*

citrus plants, and Hattie Brainerd became the island midwife and was appointed Captiva's postmistress in 1903, serving there for thirty-five years. The post office was a box-like enclosure in her home that was not more than a thatched hut.

The northern end of Buck Key was homesteaded by Henry Knowles, a Georgia farmer, who came with his wife, Julia, in 1897. They grew grapefruit, new in the United States and in much demand in the North. Captain and Mrs. George Ornsby, along with their daughters, Ida and Louise, came to Buck Key about the same time as the Knowles family. They decided to homestead the south end of the island, and George's brother William owned sixty-seven acres next to them. A school district was organized in 1897 for twelve students.

During the next four years, Ornsby paid $2.50 for the seven students who remained in the school to be educated, but the teacher left. The children then transferred to the school in Captiva, and their families relocated there also. For one winter season, January through May 1914, Professor Clarence Snyder used the buildings for his "Outdoor School." Without any more permanent residents, the island quickly returned to its natural vegetation. When it was threatened by high-density zoning in the 1970s, Mrs. Elena Duke Benedict, the owner, donated her two hundred acres, worth more than $1 million, to the Nature Conservancy in honor of her family. Benedict Wildlife Sanctuary was dedicated in January 1979.

ROOSEVELT CHANNEL (#3)

Captiva was celebrated throughout the country for its excellent fishing. Theodore Roosevelt decided to visit Captiva to study devilfish and sharks. He traveled with scientist Russell Coles, and together they intended to prove that the big fish were edible and their skins could be used commercially. They built a barge with a house on it and anchored off Captiva in the bay, getting supplies and picking up their mail from the island store and the post office on Captiva. While in the area, the two men ordered sharkskin shoes and wore them proudly. The men were even able to persuade a few Captivians to eat shark, but none would try the devilfish.

During this time, a little girl was anxious to get the autograph of the former president. Margaret Mickle, who lived with her family on Captiva, had a telephone operator friend in Fort Myers who desperately wanted Roosevelt's signature. Sailing in a leaky boat, she headed for the barge, camera ready. However, the boat finally sank to the bottom, and Maggie

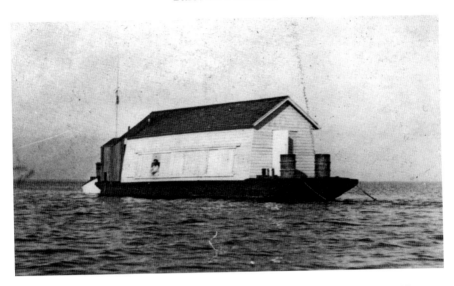

Teddy Roosevelt's barge anchored in the Roosevelt Channel. *Courtesy Sanibel Public Library.*

swam the rest of the way, holding up her camera to protect it. Though no strangers were allowed aboard the barge, the crew, realizing her problem, snatched her from the water. When she asked, "Where's Teddy?" the girl was advised that no one could bother him. She's reported as stating, "All my life I wanted to shake a president's hand, and I'm not about to leave without doing it now." The commotion brought Roosevelt to the deck roaring with laughter. "Anyone who calls me Teddy can see me," he said. He invited the girl inside for a bite to eat. She left that day with a wonderful story to go along with her treasured autograph!

IN HARMONY WITH NATURE
Captiva Road

In 1896, postal service was set up on the Captiva bulkhead in the bay. The mail was brought daily, except Sunday, by boats plying between Fort Myers and Punta Gorda. They left at six o'clock from both places and met the same time at the Captiva bulkhead—one was going south, the other going north.

The first motorboat to carry mail on the islands was owned by Mason Dwight. Lewis Doane carried the residents' letters from Wulfert to the bulkhead on Dwight's motor launch. This operation lasted until 1903, when Hattie Brainerd opened a post office on Captiva.

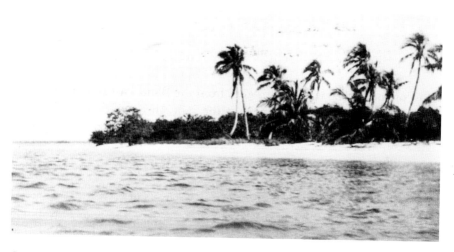

Captiva, circa 1938. *Courtesy Sanibel Public Library.*

THE EARLY SETTLERS

Tobe Bryant and his family moved from Useppa to Captiva in 1899. They lived in a palmetto hut and planted avocados, vegetables and fourteen acres of citrus. In 1903, Bryant ran for state representative on the Socialist ticket and was defeated. With his family bursting at the seams, he built a larger house a half mile from the beach, wisely putting wooded areas, a swamp and an oil ridge between them and high tide.

Joseph P. Wightman arrived on Captiva in 1917. His family bought a house covered with palm fronds built on land stretching from the Gulf to the bay. According to Wightman, there were forty to sixty people on the island, either farmers or fishermen. The children amused themselves by playing games like last tag and baseball. They wrapped rags around a ball of cotton for baseballs and used homemade bats.

Avid fishermen, they kept only enough to carry home. Wightman states, "We practically lived on fish and vegetables from their gardens because there were not many other ways to earn money."

When the locals did find work, it was too difficult to travel around the island. So they camped outside the farm or building site until the work was finished and then returned home. That's when they'd catch raccoons or other wildlife and cook them up on outside fires. This pot of food Wightman called "purloo." "There weren't as many raccoons then as there are now. Some people would par boil the raccoons first until the meat was ready to fall off the bones, allowing the fat to rise to the top, and then bake them. To absorb the grease, farmers would throw in rice, leaving nothing to waste."

THE GOLD COAST ATTRACTS THE FAMOUS

Most of the people who built homes from the Blind Pass Bridge to Tween Waters Inn had been vacationers at the inn. Alice O'Brien purchased a six-hundred-foot parcel and encouraged friends to build on land adjacent to hers.

Alice O'Brien

In 1945, O'Brien was instrumental in the creation of the Sanibel National Wildlife Refuge. As a young woman, she was quite a traveler, venturing to Africa to photograph pygmies. From a well-to-do family, she owned a car

Alice O'Brien aboard her boat, the *Wanigan.*
Courtesy Sanibel Public Library.

and a boat while still in her teens and was well versed in the skills of a navigator. A mechanic in Europe in World War I, she switched to driving ambulances since there were few trucks.

This world traveler first started coming to Captiva in the 1930s to fish with several friends. After staying at 'Tween Waters, she decided to build a house and several cottages that later became known as the O'Brien Compound. At about the same time, O'Brien purchased a seventy-five-foot-long yacht, the *Wanigan,* and hired a Norwegian captain. She gave him a small house close to the bay that was later used as a guesthouse. O'Brien had to give up the yacht when it was requisitioned by the navy during World War II.

Captain Belton Johnson

This well-known fishing guide to artist and conservationist Jay Darling lived on Sanibel as a child and moved to Captiva in 1935. Johnson's father came to the island in 1901 to pick tomatoes for Frank Bailey. In an interview with Gloria Berry for *True Tales of Old Captiva,* Johnson talks about bootlegging on the islands: "I'd go to Sanibel and get the whiskey and brought it back to the people on the yachts. Some of it came from Cuba…Sam Woodring had some, but he wasn't in it by himself. Sam was one of the finest men I knew… he had the largest funeral of anyone I ever knew."

In 1942, Johnson met and married Miriam Malone Williams and settled in a house that was later destroyed in the 1944 hurricane. Although Johnson was kept busy with fishing charters, he only received six dollars a day after having to supply the boat and gas.

When he first came to Captiva, the residents dug holes in the sand to get surface water. He claims it had a little shell taste but was okay to drink. For eight years, he also worked for Alice O'Brien as captain of her yacht,

Wanigan. During this period, Johnson saw interesting parts of the country, skippering the craft through the Great Lakes and up the East Coast to Maine.

The Dickeys

Dr. John Dickey, his wife, Julia, and their sons Herman, Carl and Ernest were Captiva's first winter residents when the pharmacist and the concert pianist fell in love with the island. They arrived on the island for the season in December 1906 with a maid, five trunks of clothing and enough supplies for a small army. Since the wind was blowing so strongly, their small, overloaded boat went aground. With no other choice, the passengers slogged three and a half miles to the house. However, during the night, the boat swamped and sank. In all the sodden mess, one item remained dry—a casting net in a tin container.

Undaunted by this experience, the couple searched for the right piece of property. Dr. Dickey and William Binder—the first homesteader on Captiva—sealed with a handshake a deal for purchasing a parcel of land. This homesite was a half mile long and extended from the Gulf to the bay north of the S curve. At that time, it was more than twice as wide. Contracting to build the house was not easy. The first man quit because of mosquitoes, and the second couldn't read the blueprints. Finally, Tobe Bryant was hired for the job.

The Dickeys returned every winter and gave land away to their friends under the condition that they would build and spend the season on Captiva.

The boys were educated in their own little red schoolhouse. This structure was composed of a classroom on the ground floor and an apartment above for their tutor. Reba Fitzpatrick

Dr. Dickey, one of the early landowners on Captiva. *Courtesy Sanibel Public Library.*

The Reba Fitzpatrick house. *Courtesy Sanibel Public Library.*

traveled with them from Virginia and taught the boys for many years. She was given a piece of land at the south end of the Dickey property, and Herman, Carl and Ernest built her house there. In 1925, this piece was sold to Bowman and Dorothy Price, who built a cottage-type hotel, 'Tween Waters Inn, in 1931. Miss Reba's small house was incorporated within the new hotel and is now the entrance to the present dining room.

The three boys loved the island and stayed in the area after reaching adulthood. Carl married and operated an "automobile laundry" in Lakeland. Later, he moved to Virginia to help work on his wife's family farm. His second daughter, Julia, was named after her grandmother. In 1929, Carl, his wife, Elizabeth, and their children returned to Captiva. Especially ingenious, he built a generator with a series of Delco batteries for their home long before electricity came to the island. Lighting was limited to one bulb per room. Carl Dickey, extremely friendly, invited famous people who were visiting, like Anne and Charles Lindbergh, to their home for dinner.

Julia Dickey Scott grew up as a privileged child on Captiva in the 1930s and remembers crabbing with her father, Carl, and the Lindberghs. Though she attended school on Sanibel, when the grades ended, her parents rented a house in Fort Myers so that the children could live at home while they went to school.

'TWEEN WATERS INN (#4)

This hotel, owned by the Price family, was a small cluster of six cottages. A 1931 guest book at 'Tween Waters shows that the inn could only accommodate six people. While two bedrooms were guest rooms, overflow slept on the porch, and most guests paid five dollars a day, American plan.

The little hotel was open from November until May, but January, February and March were the busiest times. Because of its popularity, the Prices had to build a new cottage every winter until there were seven. The Prices claimed that they never made much money.

Guests visiting by car would take the ferry and then call for a taxi, or the owners of the hotel would pick them up. Others disembarked at Pop Randal's dock on Captiva in a little amphibian plane. Supplies for the inn, like kerosene, gasoline for boats and ice for the iceboxes, were dropped off by the Punta Gorda fish boat several times a week.

'Tween Waters Inn hosted many famous guests, such as Jay "Ding" Darling. The cartoonist and his wife, Penny, arrived in Captiva in March 1936. Impressed with the island, they returned with a trailer, the Bouncing Betsy. They eventually built a home at the end of a dock with a drawbridge

Dining room entrance to 'Tween Waters, originally the Reba Fitzpatrick house. *Photo by Manfred Strobel.*

on it, which was pulled up when Darling was working. Much of their time, however, was spent in a cottage at 'Tween Waters Inn, leaving their house to guests.

Darling was the one who named the hotel. Originally it was called Mrs. Price's Inn, but then Darling suggested changing the name to 'Tween Waters for its location between the Gulf and the bay.

He was known by the locals as a very generous and kind man. When Bowman Price was ill in 1937, Darling hosted a New Year's Party. Price's bedroom was in the front. Darling threw a traveling cocktail party and made a sign saying "Doc Price's Medicine—picturing a large cartoon." The first stop was at Price's window to give him a little New Year's cheer, and then they traveled down the island, stopping at all their friends' houses.

Bowman Price left the island that January and died shortly after. While he was in the hospital, Darling sent him a cartoon, note or sketch every day to cheer him up.

During World War II, the inn acted as a respite for many of the men serving in the Coast Guard. Sometimes they knocked on the door asking for water. Then the whole patrol would march in because the cook would have made a couple of extra pies and offered them to the men.

THE FENTON HOME (#5)

Built in 1934, this house features iron door straps that were hand-forged by George Fenton, using worn-out saw blades from his marble quarry in Tennessee. Fenton came to the island with his wife, but before the house

The George Fenton house today. *Photo by Manfred Strobel.*

could be completed, she died. According to local sources, it was supposed to have been patterned after Ramona's Mission located in California.

He made most of the furniture himself, all from old burned brushed oak. The headboards had little mission bells swinging up into the air, and he did all the wrought iron himself. Fenton remarried and, after a few years of living in the house, sold it.

TIMMY'S NOOK (#6)

Beulah Brainerd Gore returned to her native Captiva with her new husband, Timmy Wiles, eleven years after her family moved to Tampa. Wiles owned a concrete block business and ran a truck for a public utilities company, but by the 1950s, he was semi-retired due to poor health. Bored, he decided to build a small eatery. Using a block machine, he poured cement, made the blocks and set the concrete floor. A dockside restaurant called Timmy's Nook opened in 1950. It was the place for casual lunches and dinners on Captiva for more than fifty years. Beach attire, a blaring jukebox and barstools adorned with various island characters added to the ambiance inside. This was a place where locals flocked to sample the wonderful seafood dishes.

Up until a few years before the causeway was built, the mail boat made stops at Punta Rassa, Bailey's dock and Timmy's Nook Marina. Following Timmy's death in 1970, his daughters took over the restaurant until it was sold. It has since been torn down and replaced by another establishment.

THE CHAPEL AND THE CEMETERY

Chapin Drive

Religion played an important part in the lives of the early settlers. Though Captiva was smaller than Sanibel, residents still were forced to travel by foot or boat to move from place to place. The formation of a cohesive community was of utmost importance at this beginning stage on the island. People needed somewhere to meet, educate their children, pray for God's blessings and bury their dead.

CAPTIVA CEMETERY (#7)

In 1896, Herbert and Hattie Brainerd and their two children, Gordon and Ann, left Quebec and headed for Captiva Island. Before leaving, Ann and Gordon's grandparents gave them each a gold piece. For five years, the family earned their living growing citrus on Buck Key. During this time, mother and daughter would often row across the narrow channel between Captiva and Buck Key to Ann's special spot, located on top of an ancient Indian mound.

The gentle slope above the Gulf waters was a perfect spot to watch the sunset. One day in 1900, nine-year-old Ann, deciding to buy that piece of land, approached the original homesteader, William Binder, and offered as payment the gold piece from her grandparents. Binder agreed to the request.

After they moved to Captiva in 1901, tragedy befell the Brainerd family when Ann accidentally stepped on a nail, contracted tetanus and died within a week. Heartbroken, her parents buried her in her favorite spot and

Annie Brainerd's tombstone at the Captiva Cemetery today. *Photo by Manfred Strobel.*

purchased the surrounding ten acres of land, donating it to the islanders for use as a community cemetery. Unfortunately, Gordon and Herbert Brainerd were the first homesteaders to be buried there within the next ten years.

CHAPEL BY THE SEA (#8)

A schoolhouse, twenty by thirty feet, was built on Captiva in 1901 near the Gulf beach on the Binder property. Classes began in January 1906 with seventeen pupils taught by Mrs. T.M. Wilkinson. The structure also doubled as a church, and services were held once a month by a traveling preacher. Parishioners arrived on foot or by mule-drawn wagons, bringing enough food to last them the entire day. They picnicked between morning and evening services. The children played games, while their elders enjoyed the shade of the spreading sea grapes. The men were off to one side swapping stories, as their wives swapped recipes and gossip. Once, when this building caught fire, the teacher and the older boys fought the flames. The boys climbed on the roof with water and managed to save the building.

The Chapel by the Sea today. *Photo by Manfred Strobel.*

Captain Faidley, a woman with skipper's papers, was one of the many teachers at the school. Her husband, who loved to fish, had broken his back and couldn't row. Each morning, she set him adrift and asked her pupils to keep an eye on him. He floated contentedly for hours until school was finished. Then she'd row out in another boat and fetch him home for dinner.

Parishioners were called on to contribute time and effort to the school/church. At first, a minister was invited to stay overnight, receiving free dinner and breakfast from one of the parishioners. As soon as the parish became prosperous, a full-time minister was hired for the season. As the congregation grew older, they found the chairs to be less comfortable, and a decision was made to buy pews. Members of the congregation, Susan Karr and her husband, built the altar, and their son helped construct the archway behind the communion table.

In 1917, the county combined the Captiva School with the Wulfert School on Sanibel, but the structure continued to serve as a chapel. When it was severely damaged by the hurricane of 1921, Hattie Brainerd Gore refused to allow this historical site to disintegrate and was instrumental in the restoration of the school/church. The chapel was sold to a Methodist conference in 1921 and became known as the Wayside Chapel. However, this religion was not popular in the community, and in 1948, a committee of Captiva residents purchased the property. The schoolhouse/church was renovated, enlarged and renamed Chapel by the Sea. Seasonal services are still held in this building.

THE HEART OF CAPTIVA

Andy Rosse Lane

A fter the devastating hurricane of 1910, many northerners, envisioning real estate opportunities, bought land on the island. Captain F.A. Lane, from Connecticut, purchased a strip that stretched from the bay to the Gulf and named it Palm Avenue.

Two years later, Lane constructed the Bayview Hotel, as well as a small cottage for his wife. To enhance the value of this property and create building sites, he dredged and filled in all the lowland along the bay from the hotel to a standing dock formerly used by early settlers. A small fish house and store were added to help promote business.

ANDY'S DOCK—MCCARTHY'S MARINA (#9)

In the early years, boats unloaded goods and transported people onto the island at an offshore bulkhead. A one-thousand-foot-long dock, strong enough for automobiles to cross, equipped with its own narrow-gauge railroad, carried handcarts of ice and fish between the run boat, fish house and store.

Andy Rosse bought the dock in 1940 after the previous owner, "Pop" Randall, died. Randall's wife had offered it to Rosse for $800. The fishing captain, low on funds, went to his friend Jay Darling and borrowed the money.

Pop Randall was almost as colorful a character as Rosse. A particular story illustrates his attitude and lack of business sense. One day a local entered the store and asked for an Old Nick candy bar. Pop shook his head. "I stopped

Above: McCarthy's Marina. The marina building was built in 1900. *Photo by the author.*

Left: Andy Rosse's dock. *Courtesy Sanibel Public Library.*

handling them." When asked why, he replied, "Because every time I get a box, they buy them all out right away."

Captain Andy Rosse was born in England in 1903 and, the following year, traveled to Tampa via New York. He moved to Captiva at the age of sixteen and became an avid fisherman. An acknowledged rumrunner, Rosse made sure the slot machines in the fish house were out of sight when the mail boat arrived.

After adding a small restaurant and bar, he was unable to find anyone to work in the restaurant, so he concentrated on the fish house and bar. This establishment was recognized by locals as the only place on Captiva where residents could get a cold beer. Local fishermen loved the convenience of the dock, where they were able to sell the day's catch, purchase bait, rent boats, buy ice and spend pocket money on groceries and good times. The bar's party atmosphere was so well known that Sanibel resident Jack Cole bartended for Rosse when business at Jack's Place was slow.

The dock was also a popular island hangout for folks waiting for the mail boat. Sundays became the most important day of the week when pilot Buddy Bobst wowed the locals by landing his seaplane, loaded with tourists, local newspapers and special goodies at the end of the dock.

In the postwar years, the mixture of people and sea life frequenting Andy's was eclectic and amusing. A couple of six-inch-long seahorses were kept in a tall pickle jar and danced from side to side. A live sea urchin, its porcupine-like quills moving slowly but continually, swam in a dish of seawater on the bar. Behind the bar were a monster hook and a bigger anchor, painted red by Rosse and labeled "Fishermen's Dreams."

Tourists, famous and infamous, frequented the bar. Islander Alice O'Brien hosted many all-night parties, and Rosse played the guitar while everyone sang and danced. One night, he was introduced to a Mr. Stevenson. It was much later when he learned the man was former governor of Illinois and soon-to-be presidential candidate Adlai Stevenson.

Rosse met his wife, Dessa, in Punta Gorda; she was fourteen. In 1924, they traveled by boat to Fort Myers and were married. Enjoying a gypsy lifestyle of trekking from place to place, they finally arrived on Captiva in 1926. Dessa's mode of dress was a halter top and bloomers while cooking and serving the meals. When a man from the health department complained and demanded she wear more clothing, she threw him out of the bar. She stopped waitressing but kept her same attire until she died in 1966.

Rosse, like most islanders at the time, was suspicious of outsiders and wasn't too fond of new residents. Stories about him are legend on Captiva. One day, a salesman was trying to sell Rosse an advertisement to bring in more people. His reply was typical: "Nope, too many folks now. Summer

spoils the pleasure of winter. Used to make a 'git by' life for years an' years. Now work the year around. Now so miserable, I hardly speak to my wife. Too many people."

Andy Rosse died in 1983. The marina building at McCarthy's dates back to the early 1900s. The present owner purchased the property from Rosse's children.

ANDY ROSSE LANE (#10)

Palm Avenue was eventually renamed Andy Rosse Lane after Captiva's most beloved character.

THE ISLAND STORE (#11)

In the summer of 1911, Captain Lane built an annex to his hotel, adding a storeroom and barbershop to the first floor. Originally, this was a two-story boardinghouse used occasionally by younger boys attending the Snyder School. In 1940, it was bought by Jay Darling and converted into a grocery store. Beulah Davis was proprietor. Davis, unable to handle the store after her husband's heart attack, asked Ina Watson to help out. Watson was such

The Island Store today. *Photo by the author.*

a good worker that in 1949 Darling asked her to run the establishment as a store and restaurant.

In an early interview, Watson talks about her inexperience with the store: "There was nothing in it…it was an empty building." She wasn't sure what the inventory should be. At first, she sold groceries and sandwiches but knew nothing about pricing. For the first year, oyster stew sold for ten cents a cup and ham sandwiches for twenty cents. When her husband, Paul, returned from Chicago, he had a fit. Up north a ham sandwich was fifty cents. After that, Watson raised the price to forty-five cents.

Often during this time, the building doubled as a storm shelter. While people waited for hurricanes to arrive, they drank and partied. Before long, it would become unbearably hot and crowded. Watson tells the following about the hurricane of 1946:

> *People wanted to know if they could come to the store because it was the most solid building around, so they all got together there and stayed through the storm…we all had plenty to eat. When the men looked at the barometer, they'd get so excited that they'd have another drink…because it was so hot with all those people, we opened the windows on the south side…all of a sudden the wind came in and blew all the gas lanterns out…the women and children started screaming…but the men were drunk on the floor and couldn't help us.*

Parker Mills purchased the property from Darling in 1949 and ran it until 1952. The inside was different than it is today, more rustic, with wainscoting on the walls, a counter all around and tables along the outside. The downside for Parker was that he had to be there at night when the dining room was open. People bought groceries while they were having dinner. Signe Wightman, celebrated for her cooking, ran the restaurant and offered a smorgasbord every Saturday night. Mostly locals ate at the place, but sometimes renters did, too. Pin Mills tells a wonderful tale about Signe:

> *It was family style, and every night we would have a signature dish. There were some people on the island who were looking forward to rabbit, because they knew Signe raised rabbits on her farm in Fort Myers. So she agreed to have hasenpfeffer, and she announced it. There was no phone in the store, so people would come in and ask what was for dinner. When this one couple heard, they shrugged their shoulders and said they'd be back the next day, because they didn't like rabbit. Signe served the rabbit and it was wonderful…everyone enjoyed it. The following day, the same couple returned, and Signe told them that chicken a la king would be that night's*

dinner. They were delighted with the choice of chicken and arrived that night for dinner. Well it seems that Signe had some rabbit left over and used it for the chicken a la king. The couple was so pleased with the dinner that they went back to compliment Signe. "That was the most delicious chicken a la king we've ever had. We hope you'll have it many times again!"

Neighbors were always helping one another on the island. In 1971, the Millses sold the store to Dick and Dee Hahn. Five years later, Dick suffered a heart attack, and an army of Captiva residents came to Dee's aid. They took over, assuming all the responsibilities of unpacking, labeling, stocking and delivering orders. These were not close personal friends but longtime customers. In 1976, George and Louise Tuttle bought the store and sold it years later.

THE KEY LIME BISTRO (#12)

In early 1951, Bill and Mae Shannon started the Sunshine Restaurant, which later became the Captiva Inn. Mae was noted for making the best key lime pie anywhere. According to old-timer Lucy Bixby:

The Key Lime Bistro today was originally the Sunshine Restaurant. *Photo by Manfred Strobel.*

Mae Shannon served awfully good food. On one special night a week, she'd serve roast beef, and it was delicious. I think the whole meal cost five dollars. She didn't serve drinks, but guests who arrived had plenty, and we did a lot of table hopping. It was a festive atmosphere, with everyone singing. They did barbershop harmony. It was really an occasion to have dinner at the Shannons'. Everyone wanted to be there.

But not everyone was having such a good time on the island. Lucy tells an amusing story about an unhappy tourist. Her husband, Ralph, was at the ferry on Sanibel trying to make a phone call from the only phone on the island. He overheard a big burly man talking to his friend: "Jim, you've got to get me off this island…what's the matter with the island? It's full of bird-watchers and shellers. I've got to go!"

Now known as the Key Lime Bistro, hundreds of hungry visitors still come to the restaurant looking for a delicious piece of key lime pie.

THE MUCKY DUCK (#13)

In the 1930s, the Mucky Duck was originally a teahouse known as the Gulf View Inn. Owners Signe and James Wightman took in a few boarders who found themselves stranded on the island. The front lawn was a couple of hundred feet deep, and a stone wall lined with Australian pines three rows thick greeted visitors as they arrived at the beach.

Bob Onan, who came to the island in 1931, related the following story:

The first time my friend and I came from Miami, there was no place to stay, but we were told earlier that morning that Louise Blank, who ran the inn, had sent word to the ferryboat captain that she had a vacancy. Well, by the time we got there, it was long gone. But since my friend was from Wisconsin, and I spoke German also, Louise was a German from Wisconsin, we spent the night on her living room couch. She proceeded to mother me from that time on.

When Onan returned to the island fifteen years later, he stayed at the Gulf View Inn. According to Onan, Louise went out each morning with enormous buckets and returned with coquinas to cook for her broth. She baked mulberry pie with berries picked from a large tree in her front yard, along with bread and fruit salad. Customers were attracted to the eatery because of the excellent food and outstanding view, especially at sunset.

After a few years, the Gulf View Inn was mentioned in the *Duncan Hines Book for Best Eating Places in America.*

The small building was flanked by a few cottages. Often the staff would serve beer, wine and a selection of teas to their guests viewing the sunset. Due to erosion, the inn was moved three hundred feet from the beach to avert destruction from the Gulf waters.

The inn closed, and the property was sold and transformed into a private three-bedroom beach house. It remained a residence until 1975, when the Mayerons and the Webbs bought it for rental property. While at the Fort Myers Courthouse doing due diligence, they discovered an expired beer and wine license from the Gulf View Inn. It could be reactivated for $100. Because of this, they decided to open a restaurant.

They brainstormed about the type of restaurant, and the Webbs remembered a wonderful place in England. In the town of Stratford-upon-Avon, they had frequented a popular pub with two entrances. On the church side, there was a sign over the door reading "The Black Swan," while on the theater side, a sign read "The Dirty Duck." Both entrances led to the same place, a celebrated bar known to its devoted patrons as the Mucky Duck.

Hundreds of visitors still crowd the outside tables to watch the sunsets and enjoy an adult beverage at the Mucky Duck.

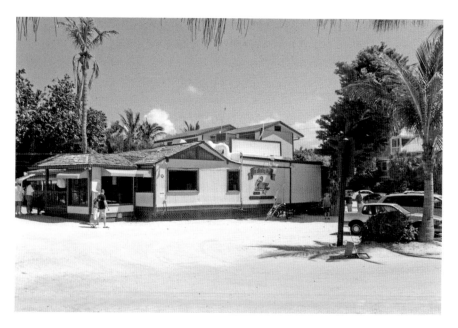

The Mucky Duck Restaurant today, the original Gulf View Inn. *Photo by Manfred Strobel.*

DICKEY LANE (#14)

This lane is named after two of the original residents on Captiva, Dr. John and Julia Dickey. Many of the original structures graced this area before Hurricane Charley devastated the island in 2004. Though several still remain today, most were destroyed and have been replaced by larger, modern homes.

Julia Dickey, who survived her husband, scrupulously kept a journal of her seventy-five years on Captiva. One of her more amusing stories concerns a pair of stockings. Julia, a target for the local paparazzi of her day, was sighted removing her stockings on the beach to shake out the sand. A week later, an article appeared in the local paper about her in the headlines: "Scandal on Captiva!"

Chapter 16

KEY LIME PLANTATION

South Seas Paradise (#15)

The beauty of the north end of Captiva graces countless photographs and postcards. Writers, artists and conservationists still flock to the area seeking the peace and solitude it affords. Early Captivians settled the island for the same reasons.

THE FIRST ARRIVALS

George W. Carter, son of an Indian fighter, came to Fort Myers in 1898 and was given a homestead grant in 1901 that included sixty acres of land on Captiva that had been formerly owned by a homesteader who defaulted. However, Carter's homestead rights were in contention for a number of years. The original landowner, Montgomery, returned a year or so later and, with guns pointed, disputed the claim. Carter stayed tough and refused to back down, eventually winning.

For many years, he and his sons successfully fished commercially and raised eggplants, tomatoes, coconuts and tropical fruits. The family used the steamboat *Gladys* to get supplies from Fort Myers or went by boat to Bailey's Store on Sanibel. Finally, in order to ship directly to the mainland, they built a long dock at the plantation.

Carter was obliged to give up raising fruit after a storm surge saturated the island with salt water, killing most of the trees. There was also fierce competition from the groves on the mainland. Before his death, Carter's children bought the homestead for $3,000, and ten years later, they sold the

property to C.W. Chadwick, the founder of South Seas Plantation.

James Loomis Sr. and Clarence Chadwick were friends. James and his wife, Ginnie, came to the island on their honeymoon in 1936 and stayed at 'Tween Waters Inn. They found washboard roads, no electricity and artesian wells with sulfur water fumes. Residents had to dig holes to bury the garbage. At that time, the northern end of the island was mostly lime groves. Chadwick, always on the lookout to make a quick buck, was very interested in disposing of his property and wanted to sell it to Loomis for $30,000 in the early '30s. The Loomises didn't take the bait, friend or no friend.

George and Elizabeth Carter, original homesteaders of South Seas Plantation. *Courtesy Sanibel Public Library.*

Life on the plantation for the Carter family was good. Children spent most of their time swimming or trying to run up the coconut trees. The girls made playhouses under the sea grapes, cutting out paper dolls from mail-order catalogues. They all attended the first island school (now Chapel by the Sea) or the second school located on land south of the homestead—property that has since eroded into the Gulf.

The Carter boys smoked almost from infancy. There's a story told by Carter's grandson John. He recalls skinny-dipping with his cousin J.B., who left his pipe in his pants before going swimming, thinking that it was extinguished. Needless to say, it wasn't, and the embers completely burned his clothes. His brother Leslie refused to lend him any of his own clothes, claiming that the mosquitoes were too thick. J.B. was forced to sprint back home naked. His dramatic appearance at the house completely upset a religious meeting that his mother, Bessie, was holding.

The first library on Captiva was a room inside the John Dickey home. Between the years from 1960 to 1962, books were delivered from Boca

Grande by the schooner *Papyrus II*. Hazel Roberts became the first librarian, ably assisted by Pin Mills, but since there were too many books, Karl Wightman helped the islanders build a memorial library in 1970.

Robert Knowles was six months old in 1897 when his father, Harvey, fetched him from Inverness to Punta Gorda. The baby had been laid on a pillow in the family's covered wagon so that he could watch the flapping of the canvas cover and be content. In Punta Gorda, the parents sold the wagon to pay steamboat fare to Captiva. When they arrived on the island, they had only fifty cents left, and that was used to buy a hoe for Harvey, who went to work for Tobe Bryant.

The Knowles family lived at the Bryants' house until they were able to build a Cheekee hut. This home had a sand floor covered with seashells to help keep down the dust. Before long, Harvey Knowles was cutting buttonwood and loading it into a sailboat for delivery to Fort Myers. Robert and his mother often tagged along, sleeping together on a mattress on deck. Robert eventually became a mail carrier but left the island to earn his teaching certificate in 1917 and was later drafted. After spending a year in the army, he married and returned to Captiva to teach school. The hurricane of 1921 destroyed the family's farm, forcing the Knowleses to move to the east coast in 1922.

Sweets were never plentiful in the early days, and the Bryant and Carter families were innovative enough to raise sugar cane on Captiva. At grinding time, a crude mill turned by mules crushed the cane. The juice was poured into big kettles or vats to boil and became sweet island syrup, a moneymaking commodity.

POSTAL SERVICE

The Captiva Post Office was established on August 29, 1901, on the Captiva bulkhead, about half a mile from shore, and Granville Hunter Bryant was the first postmaster. When the office was officially moved on shore in 1903, Hattie Brainerd became postmaster, while her husband continued to farm. But he met a tragic death.

There were several black men working on his farm, and one day an argument transpired, during which one of the hired men struck Brainerd with a grub hoe. In three days Brainerd was dead, and for years afterward, no blacks were allowed on the island. Hattie continued to run the post office. Some years later, she married a man named Gore and remained at her job until 1940—almost thirty-seven years.

The King's Crown Restaurant at South Seas Plantation. It's the only building still remaining of the Carter homestead. *Photo by the author.*

THE CARTER HOMESTEAD—SOUTH SEAS PLANTATION

This was a working plantation of coconuts, grapefruit and limes until the 1944 hurricane.

When Redfish Pass was created by the 1921 hurricane, many of the landowners lost their property and sold what was left to C.B. Chadwick. He named it South Seas and, to continue the plantation theme, built a manor house on the northern tip of the property. In 1945, confined to a wheelchair and unwilling to rebuild the groves in a declining market, he sold the plantation to a hotel corporation.

In 1955, according to former resident Paul Everett, the plantation house had four or five cottages and was the place to be on Saturday night for fishermen. A number of years later, the new owners added a nine-hole golf course where lime trees had previously grown.

CLARENCE CHADWICK

Clarence Chadwick and his wife, Rosamund, came to Captiva on vacation in 1923. In poor health, he became increasingly arthritic, and within three years, he was confined to a wheelchair. A glassed-in, heated swimming pool, fed by sea water, was added to his home, and this, along with frequent sunbaths, eased his stiff limbs—but not his acerbic personality. Rosamund, a nurse, was kind and outgoing and once saved the life of little Edward Willis, who had swallowed kerosene.

There were towering coconut palms on the property, and Chadwick planted more, hoping to harvest copra, the dried meat of the coconut. When the 1926 hurricane killed citrus groves at Wulfert, he bought most of the arable land and replanted them with limes. By 1940, he was building cottages on the property for people who worked for him, visualizing it as a community with a pier and post office.

In time, the Chadwicks owned 400 acres on Sanibel and Captiva, and 120 on Pine Island. The Chadwick home became the main lodge, with more than fifteen cottages providing accommodations. Wealthy and famous friends visited and sometimes opted to buy land and build homes. After the war, Chadwick sold the plantation to the American Hotels Corporation. The King's Crown Restaurant is all that is left of the original Carter homestead.

South Seas Plantation continues to attract visitors from all over the world wanting the peace and serenity of an island paradise.

EPILOGUE

And so our journey through the historical sites of Sanibel and Captiva comes to an end. I hope you enjoyed the trip. For those interested in learning more, it's not over. The tales mentioned in my book are just a small snapshot. Unfortunately, with the limitations on space and number of photos allowed for this book, many sites were not discussed and some pioneer families were omitted.

At this writing, the Green Flash Restaurant currently occupies the site of Timmy's Nook, and the actual graves at Wulfert Cemetery remain hidden under foliage somewhere on private property. I will continue my search for them.

Although a member of the Bailey family has always lived in their "teapot" home, recently the Sanibel Captiva Conservation Foundation has raised enough money to purchase the home and its surrounding land.

Paul McCarthy at McCarthy's marina is an island historian and tells wonderful stories about Andy Rosse and others during his boat tours. The Captiva Library on Chapin Drive has a display of photos, newspaper articles and books about early Captiva residents. The Sanibel Public Library has devoted a whole section to the islands' past, highlighting oral and video interviews of early settlers and their descendants.

For more information about the history of Sanibel and Captiva, visit the Sanibel Historical Museum and Village, which contains many artifacts, photos and books. Museum docents are extremely knowledgeable.

The Historical Preservation Committee continues to monitor historical sites on the islands and encourages residents to preserve their heritage by sharing family stories and photos. Researching the islands' history is ongoing so that our past will help us be better prepared for our future.

SELECTED BIBLIOGRAPHY

Anholt, Betty. *Sanibel's Story: Voices & Images from Calusa to Incorporation.* Virginia Beach, VA: Donning Company Publishers, 1998.

Board, Prudy T., and Esther B. Colcord. *Historic Fort Myers.* Virginia Beach, VA: Donning Company Publishers, 1992.

Captiva Civic Association. *Voices from the Past: True Tales of Old Captiva.* Fort Myers, FL: Sutherland Publishing, 1984.

Christman, Linda. "Bailey Brothers Delight Packed Community House." *Sanibel-Captiva Islander,* March 28, 2008.

Dormer, Elinore M. *The Sea Shell Islands: A History of Sanibel and Captiva.* Tallahassee, FL: Rose Printing Company, 1987.

Downes, Jean. "Hallie Matthews." *Island Sun,* April 27, 2001, A.

———. "Pickens Remembers Islands Fifty Years Ago." *Island Sun,* March 7, 2002, A.

———. "Postal Service on Sanibel, a Short History." *Sanibel-Captiva Islander,* March 7, 2002, B.

———. "Riddle and Crumpler." *Island Sun,* July 13, 2001, B.

Fritz, Florence. *The Unknown Story of World Famous Sanibel and Captiva (Ybel and Cautivo).* Parson, WV: McClain Printing Company, 1974.

Hill, Yvonne, and Marguerite Jordon. *Images of America: Sanibel Island.* Charleston, SC: Arcadia Publishing, 2008.

Island Sun. "Sanibel's Music Man." October 3, 1997.

"Kinzie Brothers Steamship Lines." *Historic Sanibel and Captiva,* n.d.

LeBuff, Charles. *Sanybel Light: An Historical Autobiography.* Fort Myers, FL: Amber Publishing, 1998.

Magg, Jeri. "The Little Old Schoolhouse Moves Down the Road." *Sanibel-Captiva Islander*, December 24, 2004, B.

———. "A Mystical Village on Sanibel." *Fort Myers Magazine*, March–April 2003.

———. "Pioneers Remembered at the Sanibel Historical Museum and Village." *Historical Sanibel and Captiva*, December 2004, A.

Nelson, Karen. "Fishing in Pine Island Sound." *Sanibel-Captiva Islander*, November 3, 2006, A.

———. "Ralph Woodring Talks about Fishing—Back Then." *Sanibel-Captiva Islander*, November 3, 2006, B.

Nutt, Laetitia. *Courageous Journey: The Civil War Journal of Laetitia Ashmore Nutt.* Miami, FL: E.A. Sieman Publishers, 1975.

Sanibel-Captiva Islander. "Pirates Playhouse Opens 18th Season." December 29, 1981.

Tabor, Roger. "Adventure, Love and Perseverance." *Island Sun,* July 28, 2006.

Tropicalia Magazine, News Press. "Sanibel's Silent Sentinel." July 1, 2007.

Tuttle, Louise. *The Homes of Old Captiva: A Photographic Record—1900–1940,* Captiva, FL: Captiva Memorial Library, 1990.

About the Author

Jeri Magg has been freelancing for over twenty years, writing for regional and local magazines and newspapers. She and her husband, Karl, moved from New York to Sanibel in 1980 with their two daughters, Carolyn and Kathy. An avid bike rider and beach addict, Jeri has volunteered at the Sanibel Historical Museum and Village for more than ten years and has authored numerous articles about the history of the islands. Now, after thirty years of listening to innumerable tales, many told by the original pioneers or their descendants, she's compiled these stories, along with a site map in this book, so others may enjoy the islands while learning their history.

Contact Jeri: jerimagg@comcast.net

Photo by Life Touch Studios.